ROYAL ACADEMY ILLUSTRATED 2008

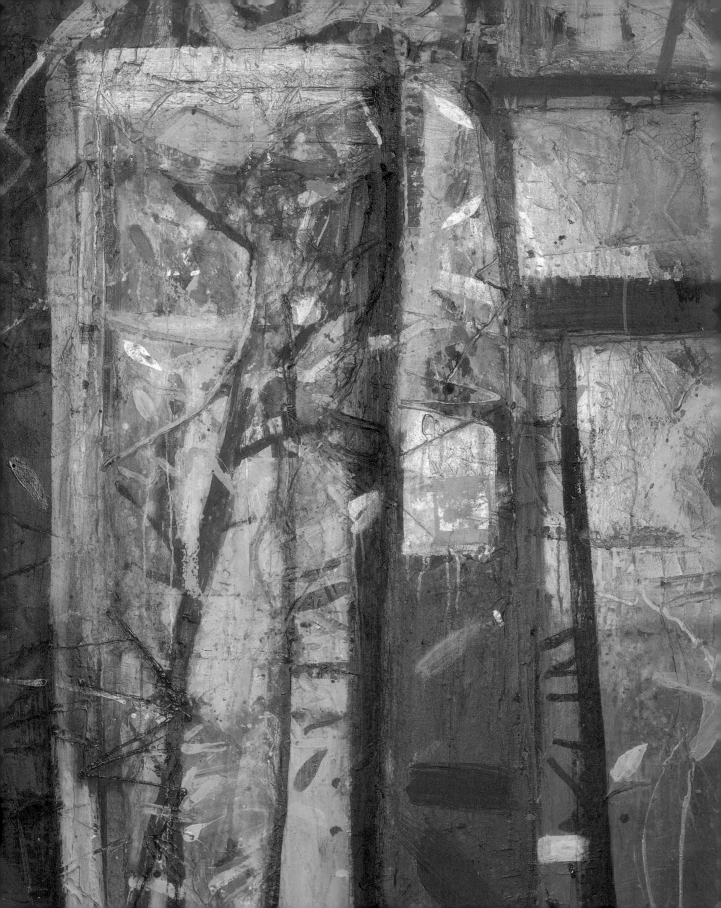

A selection from the 240th
Summer Exhibition

Edited by Humphrey Ocean RA

ROYAL ACADEMY ILLUSTRATED 2008

SPONSORED BY

ROYAL ACADEMY OF ARTS

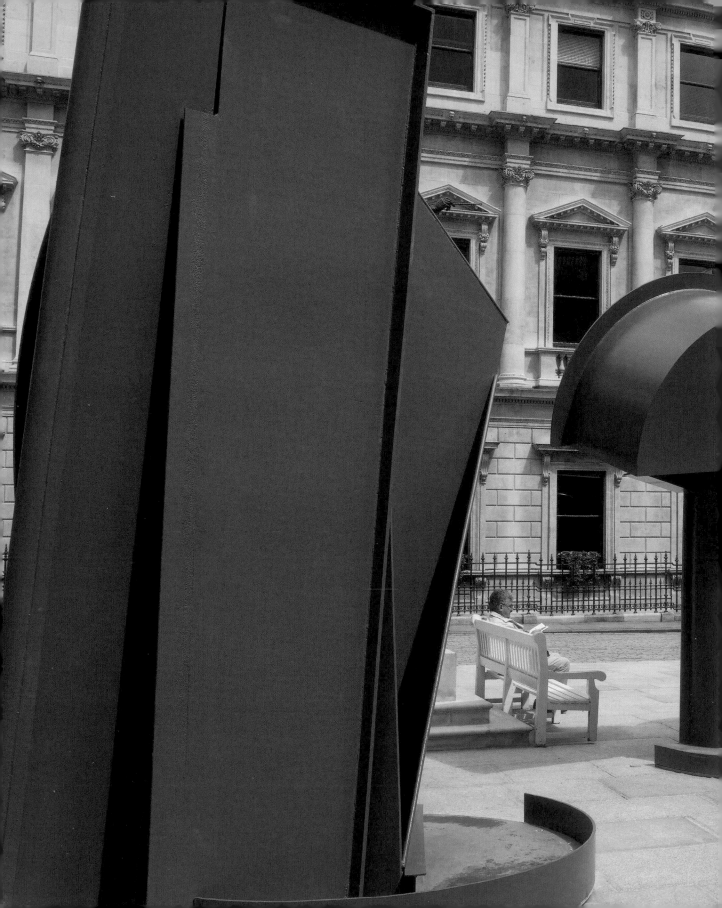

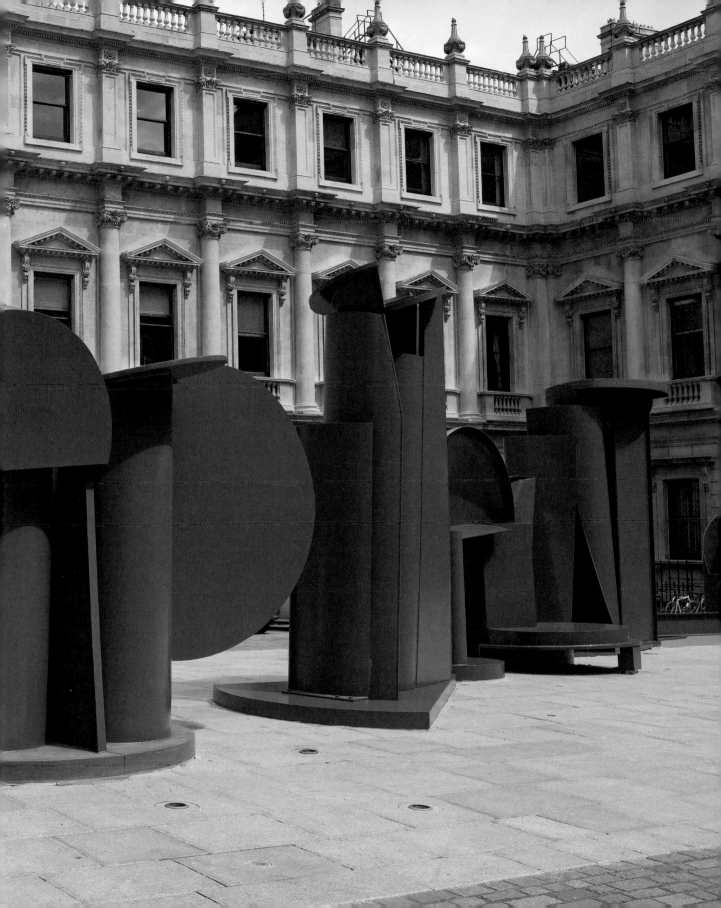

Contents

Sponsor's Foreword

Business and the Arts. The Perfect Fit.

Insight Investment is delighted, as lead sponsor, to be associated with the artistic talent for which the Summer Exhibition at the Royal Academy of Arts is renowned.

Insight Investment, part of the HBOS Group, is a specialist asset manager at the forefront of building investment solutions designed specifically to meet clients' investment needs. Indeed, Insight Investment has become one of the largest investment managers in the UK, managing assets of more than £109 billion. * We manage funds for institutional and retail clients across a range of asset types, including equities, bonds, derivatives and alternatives. Our investment platform has been designed to provide complete flexibility through a range of crafted asset classes and investment capabilities. Its breadth, depth and scalability mean that we can create investment solutions for clients regardless of size, investment need or objective.

Our continued sponsorship of the Summer Exhibition has been driven by two core values shared by both institutions: innovation and creative thinking. For us, creative thinking is about breaking new ground, taking measured risks, challenging convention and thinking boldly and differently in everything we do. These are exactly the elements that you will find in abundance at this year's Summer Exhibition, and it is these shared values that have cemented our partnership with the Royal Academy, allowing us to combine the very best from the arenas of art and business.

This is now the third year that we have sponsored the Summer Exhibition and we very much hope that visitors to the exhibition, along with our customers, business partners and colleagues, will find inspiration in the artistic diversity on display.

More Insight. Not more of the same.

Abdallah Nauphal
Chief Executive Officer

* As at 31 December 2007

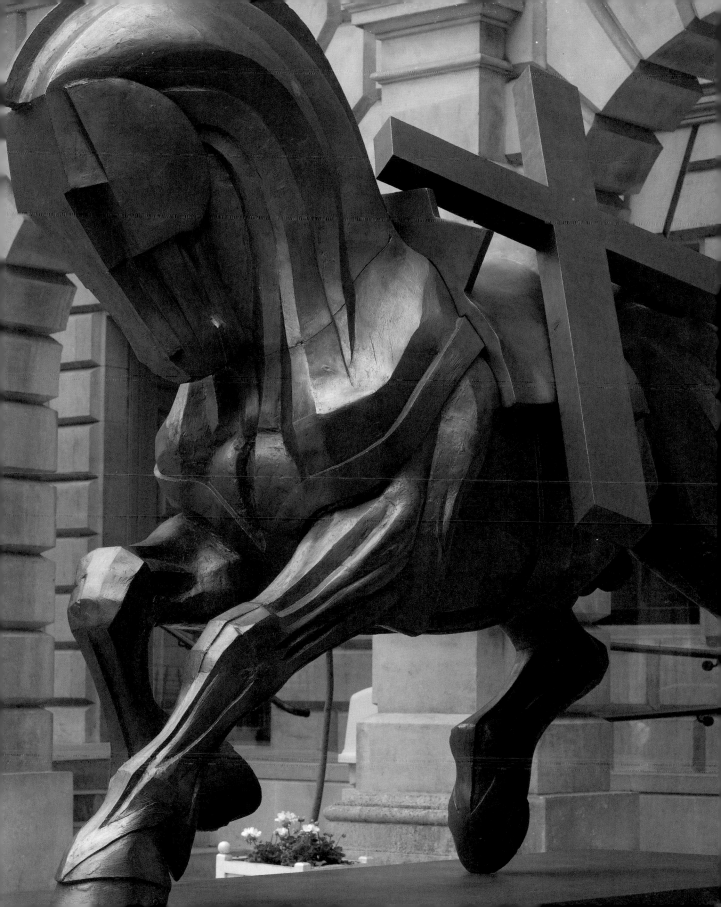

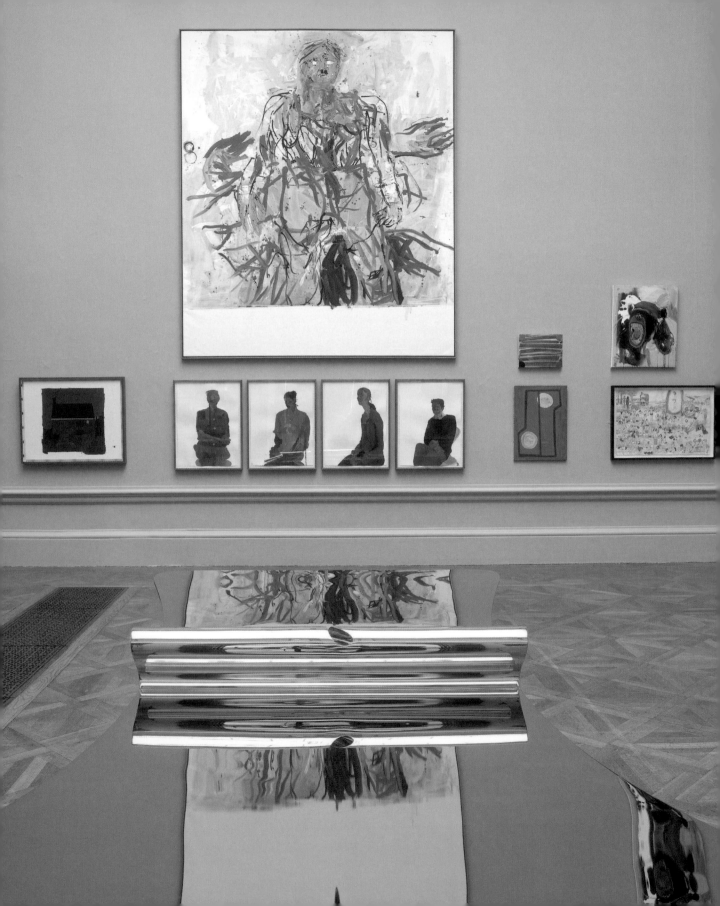

Foreword
Humphrey Ocean RA

A gold standard of loveliness in art has so far eluded us. The goalposts keep shifting. You could say beauty surprises most when used by an artist to deliver the least palatable ideas. Think about Warhol's *Electric Chair*. Lurking somewhere in the Summer Exhibition is something you will love or that moves you, as in picks you up and puts you down in another place, I am willing to bet. Chosen and hung by artists, the Summer Exhibition is unlike anything anywhere else in the world on this scale. Forget exhibitions as you know them. Here is the human mind, fired up and ready to go, in probably more guises than you are used to encountering in one building. In here, as Magritte might have said, that tree you are looking at is no longer a tree, it is now man made.

Introduction

Frank Whitford

Like the Anglican Church, that other oddly English phenomenon, the Royal Academy is a mixture – sometimes an alarmingly volatile mixture – of divergent beliefs, contradictory convictions, and conflicting rituals. The membership of both time-honoured institutions consists not only of fundamentalists, for whom yesterday always remains more reliable and reassuring than tomorrow, but also of radicals, who are permanently set on questioning and challenging dogma. Every sort of ecclesiastical or artistic opinion can be found in between. This alone ensures that the deaths of both the Church of England and the Royal Academy are regularly foreseen if not actually announced.

Some of the charm of the Summer Exhibition, like that of the Anglican Church, is derived from the impression that it promises all things to all men. There is the established artist, who visits the show in the spirit of enquiry. Then there is the little-known professional, who regularly sends in a couple of paintings, dreaming that this year will finally bring success (at the same time, however, it's clear that, since some 10,000 works are submitted each year, there's a far greater chance of disappointment). Then, finally, there are the critics in the national press, who in monotonously similar language attack the Summer Exhibition for – what else? – its annual monotony.

But no two Summer Exhibitions are the same. Nor can they ever be. For one thing, not all the Royal Academicians whose work stands out year after year are represented in 2008, actually the 240th show of its kind. It's almost amazing that there's no gigantic painting by David Hockney; nor is there anything by John Hoyland, whose blazing abstracts are usually such a feature of the show. At the same time, some old faces, unseen for years, put in a welcome reappearance. One of them belongs to the sculptor Ralph Brown, who is represented by two versions of the same image, a head of Pomona.

Reassuringly, however, there are several more or less perennial features. There's the mega-display of prints in every imaginable medium in the Large Weston Room, which includes Christoph Rückhaberle's massive, brightly coloured woodcut *Frau mit Gitarre* (*Woman with Guitar*). And there's the densely hung show of small paintings in the adjacent Small Weston Room, which also finds space for drawings, like the characteristically vigorous series by Quentin Blake. Sadly, memorial displays to Royal Academicians who have died during the year are also an almost annual feature. The space devoted to the late R. B. Kitaj is expansive and prominent, a reflection of the international reputation of this much-admired artist. The tribute to Kitaj is followed by another, this one to the architect of the British Library, Professor Sir Colin St John Wilson, who, in his guise as a distinguished art collector, began to buy prime examples of Kitaj's paintings at the start of the artist's career.

For Humphrey Ocean, in charge of hanging the paintings in this year's Summer Exhibition, diversity and conflict are two of the qualities that make the exhibition unique. 'There are several aspects to the Summer Exhibition that are found nowhere else,' he says.

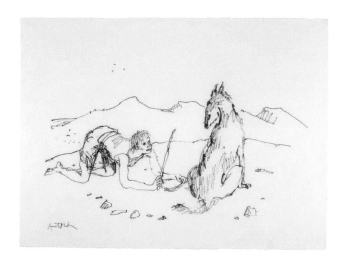

Prof Quentin Blake
CBE RDI Hon Fellow
Girl and Dog 1
pen and ink
64 × 86 cm

Sir Anthony Caro OM CBE RA
Promenade (detail)

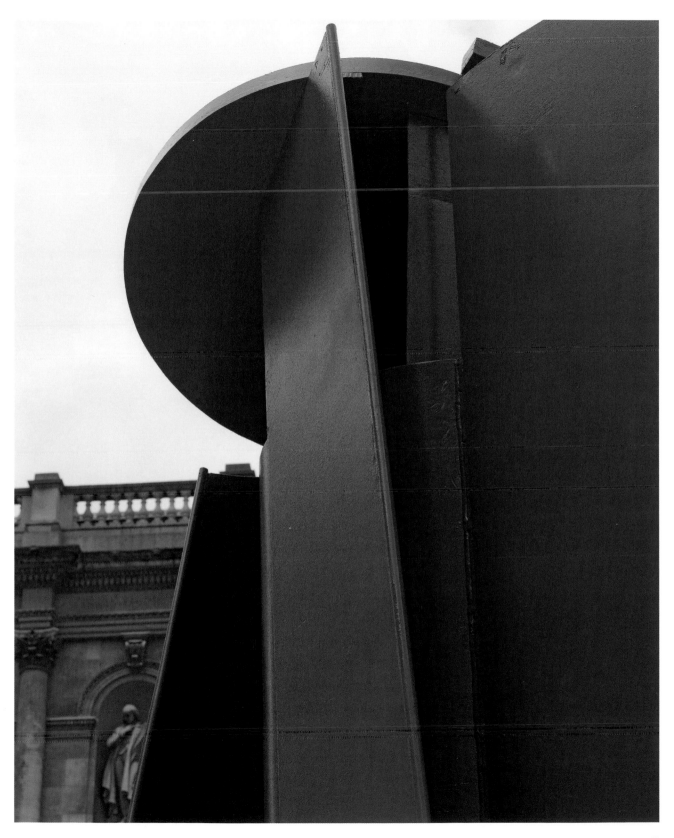

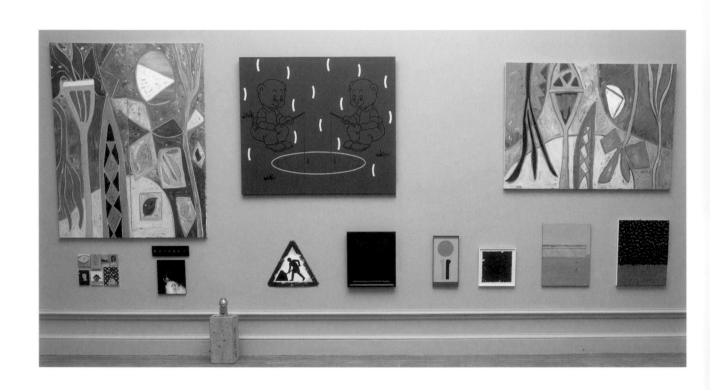

Installation in Gallery IV

'For example, we can bring together in the same show a work by someone completely unknown living in Aberdeen with one by, say, Tony Cragg, who's universally recognised as one of the finest sculptors anywhere. You don't get this sort of democratic juxtaposition in any other exhibition. And then, when all these disparate things are assembled, we hang them chiefly by eye and not according to art-historical or didactic principles.' The result is an exhibition of a kind that's truly different from the usual, and sometimes startlingly so.

There's always one gallery or one work that engages everybody's attention and provokes admiration, comment or both. This year there will surely be much talk about Sir Anthony Caro's *Promenade*, the monumental five-part sculpture in painted steel that stands like a row of sentinels across the Annenberg Courtyard in front of Burlington House, lending the entire exhibition a weight and a seriousness even before it properly begins. Others, no doubt, will be more inclined to discuss (and worry about) the anthology of works in Gallery VIII, several of them provocative, even shocking, by artists invited by Tracey Emin, a fairly recent recruit to the ranks of the Royal Academicians, and surely one of the radicals in anybody's language. Her emphasis on art with a sexual content will not appeal to everybody, and may annoy some.

Another unapologetic radical is Tony Cragg, who has co-ordinated the selection and hanging of the sculpture this year. His unwavering insistence on what is known hereabouts as a 'museum hang' – meaning considerably more space for works than is usually available in the Summer Exhibition, and, in the Lecture Room, virtually nothing on the walls but one of Phillip King's reliefs – has resulted in an undeniably beautiful, exquisitely poised display. Humphrey Ocean says, 'I knew from the beginning that Tony Cragg would go for a sparse hang in the Lecture Room and that's precisely what he did. My room, Gallery IV, is intentionally different. The hang throughout the other rooms is much denser, but the real point is, we sparked each other off creatively, and there is now an engrossing progression from one gallery to the next, from one mood to the next, if you like.'

Such a mood swing seems especially dramatic when you move from Gallery IX, a relatively spare display of sculpture, much of it abstract, to Gallery X, a tight arrangement of figurative paintings, many of them by such regular favourites as Olwyn Bowey and Frederick Gore (still going strong), on which Anthony Green has somehow managed to impose a visually imposing unity. Green is a master of difficult hangs like this, yet even he admits to an admiration for Mick Rooney's arrangement of the mostly small pictures in the Small Weston Room, many of them hung six deep, from floor to ceiling. 'It's the best hang of this room for years,' says Green, 'and that includes my own last year. Mick Rooney's pulled it off with the aid of a stratagem that not everyone will notice. Instead of beginning the hanging of each wall somewhere in the middle and working outwards, he's started with a precise horizontal line way up at the top and worked downwards from there.'

Certainly the contrasts between one gallery and another are more obvious than for several years. For Humphrey Ocean, such differences not only add to the pleasure of moving through the exhibition, they also reveal and reinforce what the Academy is all about. 'This isn't a monolithic institution,' he says, 'nor is this exhibition like any other anywhere else. For one thing we largely depend on what our fellow Royal Academicians decide to show of their own work – we have to take what they give us, come what may – and on what we choose from the submissions of non-Academicians, what we call the "send-ins". What we end up with, I think, is a kind of map that reveals the many-faceted, even confusing state of art in Britain now. Of course there are serious drawbacks to our approach and attitude. There are always some quite wonderful works that don't, in the end, make it onto the walls simply because they don't fit in with the developing scheme of things or look at their best in this particular company. Sometimes the show can seem confusing and needlessly disparate. But the world is full of beautifully thought-out, logically constructed, closely argued exhibitions. Ours isn't one of them. We offer something else. The way the Summer Exhibition brings together so many different styles and approaches is truly unique. It includes work by such formidable, world-famous masters as Anselm Kiefer and Georg Baselitz; by younger, established British artists such as Gavin Turk and Tracey Emin; and superb paintings by Fred Cuming and Anthony Eyton. Where else do you get such a variety in a single show?'

Tribute to
R. B. Kitaj RA
(1932–2007)

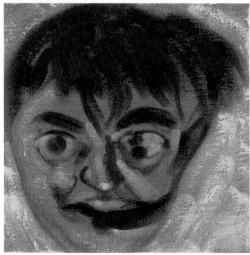

Used of painting, 'anecdotal' and 'literary' were once dirty words. They still are in some circles. Indeed, for most of the last 100 years, painting, at least in the West, has been expected to be 'painterly' and 'pure', uncontaminated by external references.

That attitude changed, at least in Britain, thanks to the achievement of R. B. Kitaj. Kitaj gave the generation of British artists that matured during the early 1960s the confidence to turn their backs on 'pure' painting and make their art tell stories, narratives that could even adopt a point of view and comment on social and political issues. Kitaj, who died in Los Angeles on 21 October 2007 at the age of 74, was always committed to art that had as much to do with the mind as the eye. His work became increasingly loaded with intellectual content, much of which had European and Jewish connections.

One example of Kitaj's engagement with these concerns is *The Jewish Rider*, actually a portrait of Michael Podro. Himself the son of Eastern European immigrants, Podro was then Professor of Art History at Essex University, and a regular traveller by train between London and Colchester; he died earlier this year.

Kitaj – the name, as the artist was fond of explaining, is the Russian for Cathay – was born in Cleveland, Ohio, on 29 October 1932. After first coming to England in 1957 to study at the Ruskin School of Drawing in Oxford, he spent more than half his life, some forty years, in this country. In 1991 he was elected a Royal Academician (having been elected an ARA in 1984), only the third American ever to have been so honoured.

Kitaj's liking for England and, more specifically, for London was sorely tried towards the end of his career, however. In 1994 critics savaged his large retrospective at the Tate Gallery, calling it self-important and self-consciously intellectual. The early death of Kitaj's second wife Sandra Fisher soon afterwards was, the artist believed, the result of the stress caused by these negative reviews. Not long after this Kitaj moved permanently to America.

Kitaj was well read and thoughtful. He packed his pictures with references and allusions, many of them arcane. It was the intellectual ambition of much of Kitaj's work that distinguished it from Pop Art, the movement with which he was initially identified, not because of references in his painting to popular culture, but because of his outstanding graphic facility, bold colours and assertive imagery, all of which are in evidence in the memorial tribute that opens this year's Summer Exhibition. *Pacific Coast Highway (Across the Pacific)* (1973) is an outstanding example of his mastery of translucent colour, pictorial structure and graphic sense.

The late R. B. Kitaj RA
Certain Forms of Association Neglected Before, 1961
oil on canvas
102 × 127 cm

The late R. B. Kitaj RA
Peter Lorre, 2005
oil on canvas
36 × 36 cm

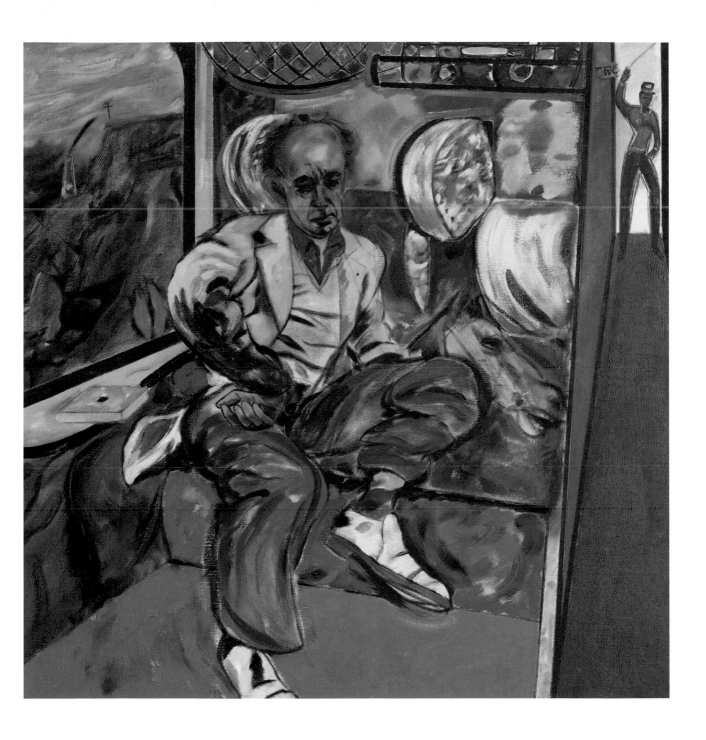

The late R. B. Kitaj RA
The Jewish Rider, 1984–85
acrylic on canvas
152 × 152 cm

Tribute to
Professor Sir Colin St John Wilson RA
(1922–2007)

One of the earliest to recognise Kitaj's importance was the architect Professor Sir Colin St John Wilson, who was elected an RA in 1991 (he had been elected an ARA in 1990), and who died aged 85 on 14 May 2007. But Wilson, known as Sandy, was not simply an architect. He was also one of the most distinguished collectors of contemporary art in Britain, and a friend of many artists, including Sir Peter Blake, Richard Hamilton and Patrick Caulfield. Soon after the Second World War, in which he served as a naval officer, Wilson started to buy work by Eduardo Paolozzi and Graham Sutherland, guided not only by an excellent eye but also by what he later described as 'the catch in the breath and the thumping heart of love-at-first-sight that signals the next ("absolute must") acquisition'.

Kitaj featured prominently in Wilson's collection, and he continued to be one of the architect's favourite painters. A huge tapestry after one of Kitaj's paintings hangs in the entrance hall of Wilson's British Library. One of Kitaj's finest portraits, *The Architects* (1981), depicts Wilson and his second wife, M. J. Long.

As an architect, Wilson, born the son of a radical clergyman on 14 March 1922, was always socially aware. He studied architecture at the University of Cambridge under Sir Leslie Martin, with whom he subsequently collaborated, and in whose footsteps he followed when he himself became Professor of Architecture at Cambridge. He shared much with Martin, not least a preference for understatement and for the then unfashionable brick. Wilson not only designed buildings, he also thought deeply about architecture and wrote about it. He was, in addition, deeply involved in the legendary and tremendously influential exhibition 'This Is Tomorrow' (1956) at the Whitechapel Art Gallery. Later, he wrote a book about the working methods of William Coldstream and Michael Andrews, *The Artist at Work* (1999).

Wilson was successful, though not, many believed, as successful as his outstanding gifts merited. His only truly major commission was for the British Library, which opened in 1997 after 35 years of cancellations, changes, delays and frustrating negotiations with government. A model of one of Wilson's early designs for the library is displayed here. When the building opened it attracted much criticism, but the library's readers, for whom the building was intended, are full of praise for Wilson's beautiful, well-lit and smoothly functioning interiors.

Wilson's last completed project was an extension to Pallant House in Chichester (designed with M. J. Long), to which he bequeathed his art collection. At the time of his death he was working on a proposal for the Royal Academy itself.

The late R. B. Kitaj RA
The Architects, 1981
oil on canvas
122 × 122 cm
Pallant House Gallery,
Chichester. Wilson Loan (2004)

The late Professor Sir Colin St John Wilson RA
The British Library, London.
Clockwise from top left: Main
Entrance; Reading Room; the
King's Library; Entrance Hall

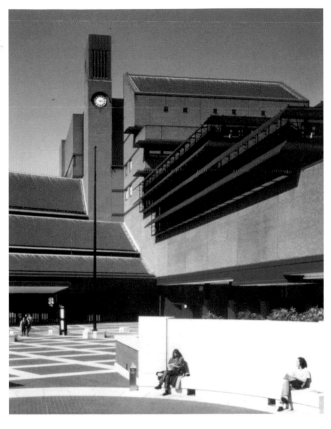

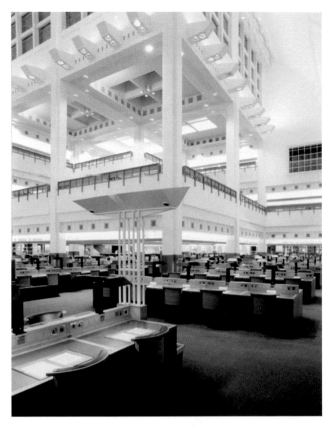

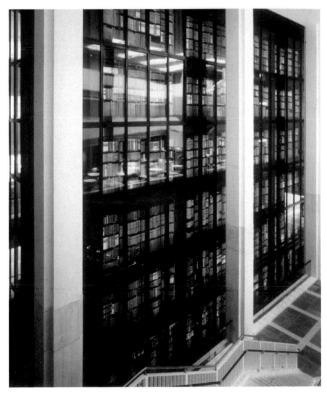

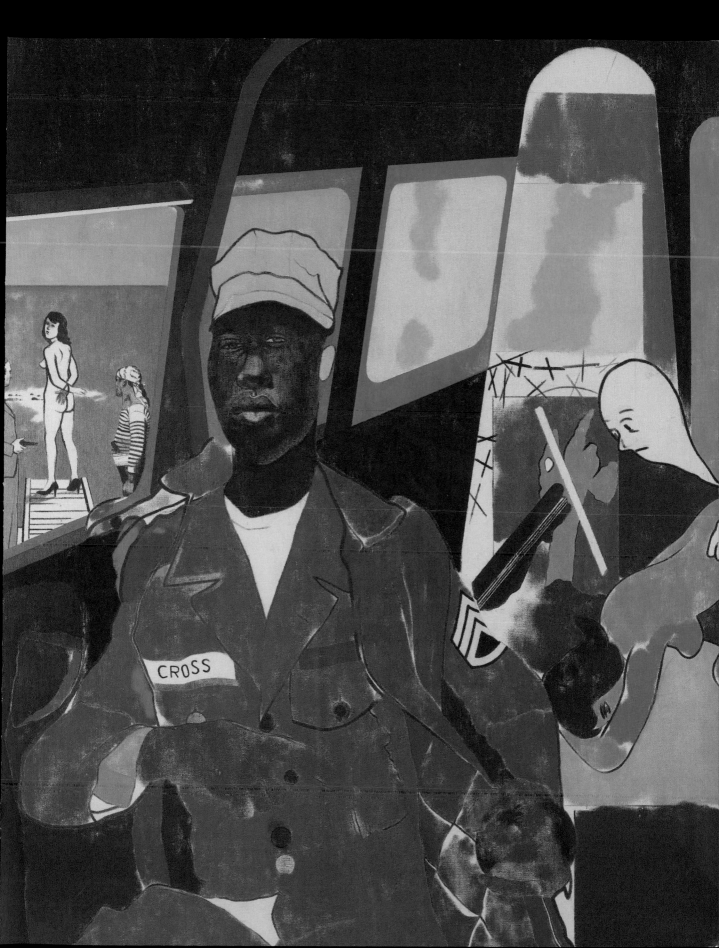

The late R B Kitaj RA
Pacific Coast Highway (Across the Pacific), 1973
oil on canvas
183 × 366 cm

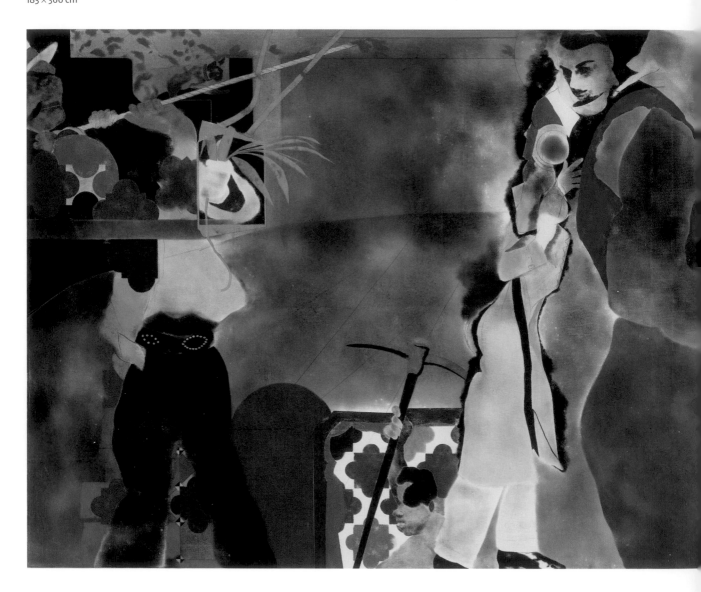

The late R B Kitaj RA
The Street (A Life), 1975
oil on canvas
103 × 80 cm

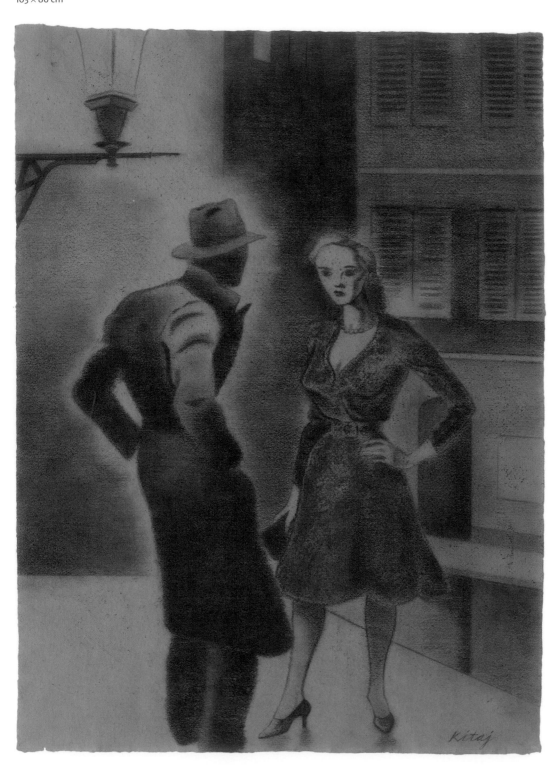

The late R B Kitaj RA
Study for the World's Body, 1974
pastel on paper
97 × 74 cm

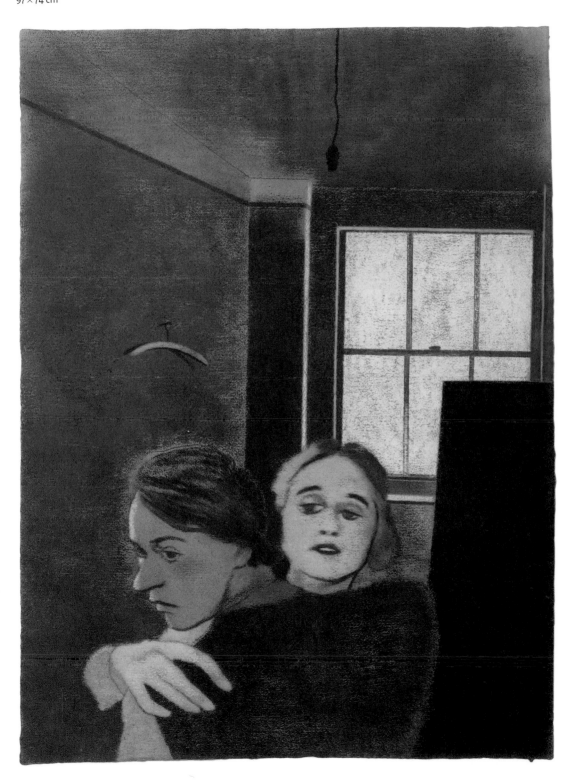

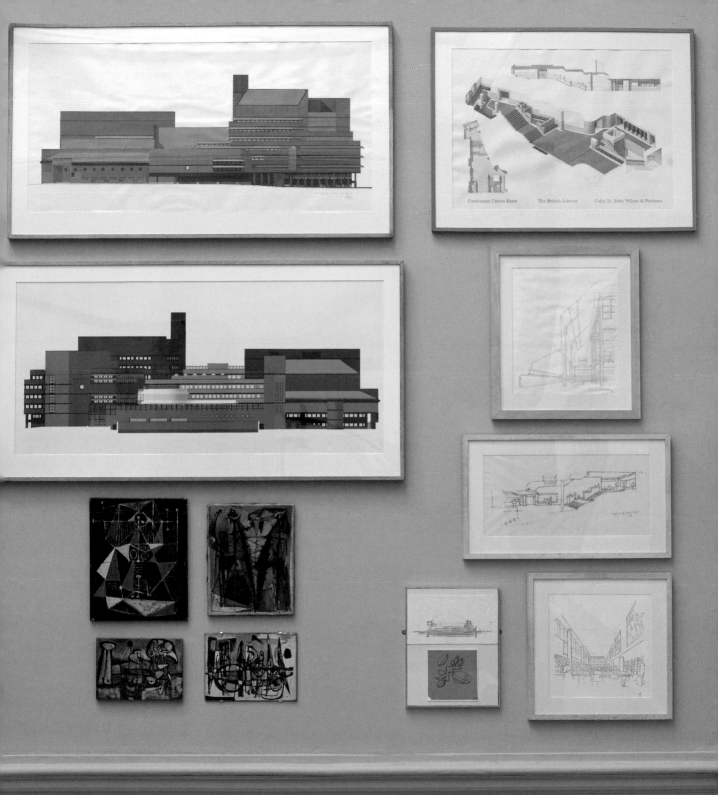

Conference Centre Foyer The British Library Colin St. John Wilson & Partners

Prof Paul Huxley RA
Z1, Purple
acrylic on linen
127 × 127 cm

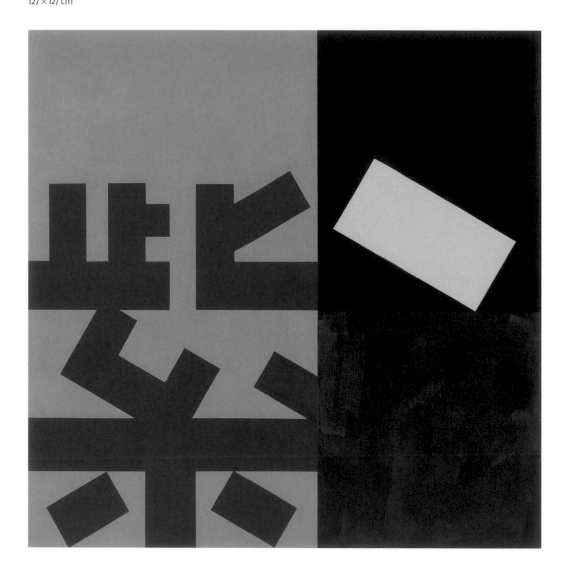

Tom Phillips CBE RA
C Loopsend
acrylic
15 × 40 cm

Ed Ruscha Hon RA
Bolts of Anger
dry pigment on paper
58 × 73 cm

Punching and Drilling
acrylic on paper
58 × 73 cm

3 Companies
dry pigment on paper
58 × 73 cm

Is it Overcast...?
pastel on paper
58 × 73 cm

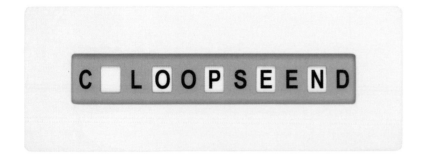

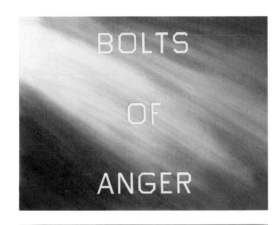

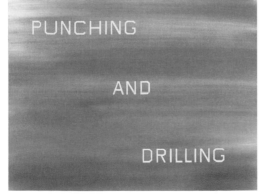

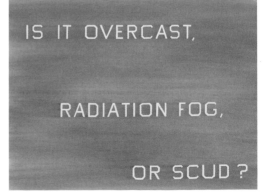

Prof Ian McKeever RA
Temple Painting
oil and acrylic on linen
270 × 420 cm

LARGE
WESTON
ROOM

Francesco Clemente
Air
woodcut
60 × 45 cm

Christoph Ruckhäberle
Frau mit Guitarre
linocut
275 × 205 cm

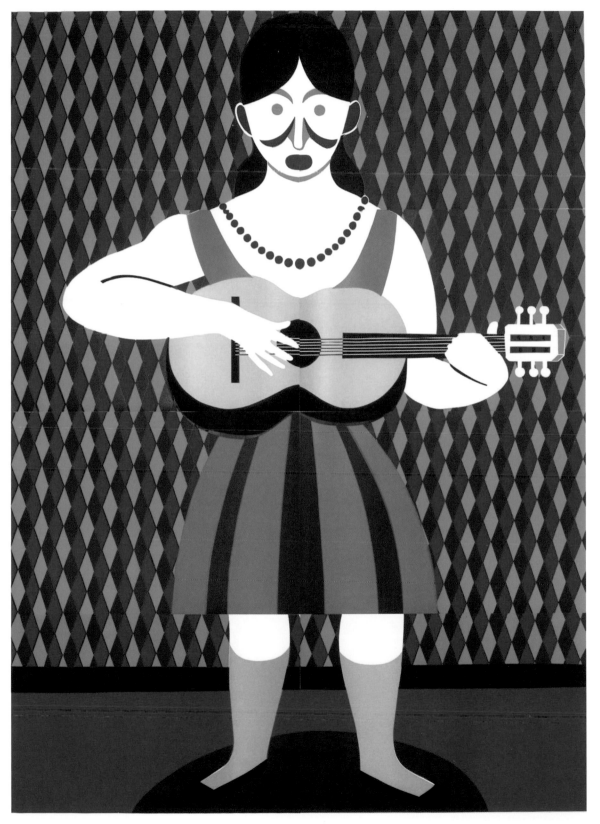

Dr Jennifer Dickson RA
Transitions: Two (Sphinx Labyrinth, Blickling Hall)
giclée and watercolour print
64 × 75 cm

Peter Freeth RA
The Tiber Near Rome, Evening
aquatint
11 × 15 cm

Prof Bryan Kneale RA
Cormorant 2
lithograph
56 × 76 cm

Lucian Freud
Donegal Man
etching
67 × 57 cm

Kiki Smith
Noon
etching
71 × 114 cm

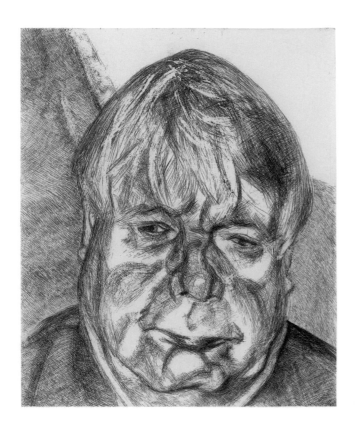

Eileen Cooper RA
Little Dramas. Scene I
linocut
77 × 92 cm

Julian Opie
Luc and Ludivine Get Married 6
laser-cut prints
both: H 45 cm

Ryan McGinness
2007
silkscreen
105 × 105 cm

Mary Heilmann
Snakey
inkjet print
60 × 95 cm

Joe Tilson RA
Stones of Venice, Sant'Alipio, Ruga
aquatint
102 × 130 cm

Helen Frankenthaler
Book of Clouds
print
90 × 170 cm

Craigie Aitchison CBE RA
Goat Fell, Isle of Arran
screenprint
50 × 40 cm

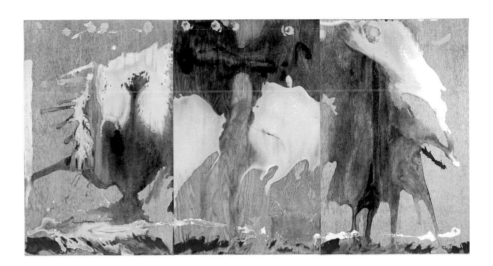

Tara Donovan
Untitled
relief print
99 × 79 cm

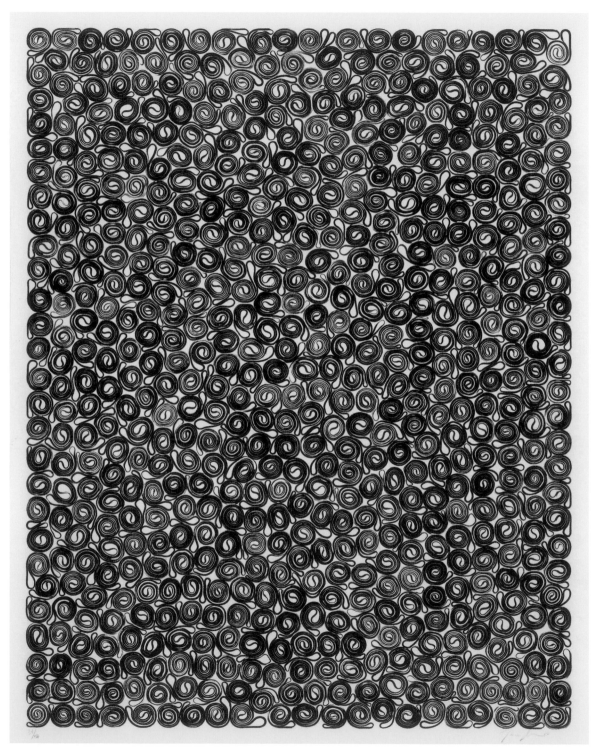

Richard Smith
Evidence I
aquatint
58 × 57 cm

Boo Ritson
Aim
screenprint with embossing
70 × 70 cm

Sir Nicholas Grimshaw CBE PRA
Structural Memories II
etching
44 × 44 cm

Basil Beattie RA
Above and Below III
etching and chine collé
73 × 58 cm

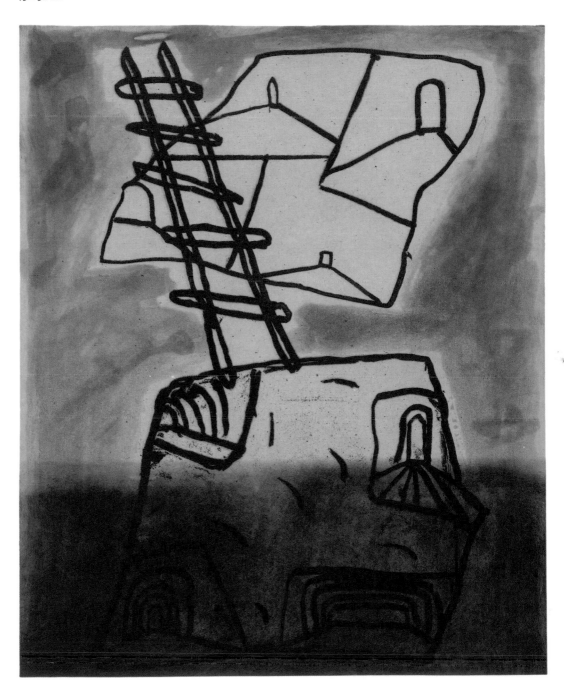

Dan Walsh
OGV–Violet
woodcut
71 × 137 cm

Donald Hamilton Fraser RA
Sangarius II
silkscreen with satin glaze
119 × 118 cm

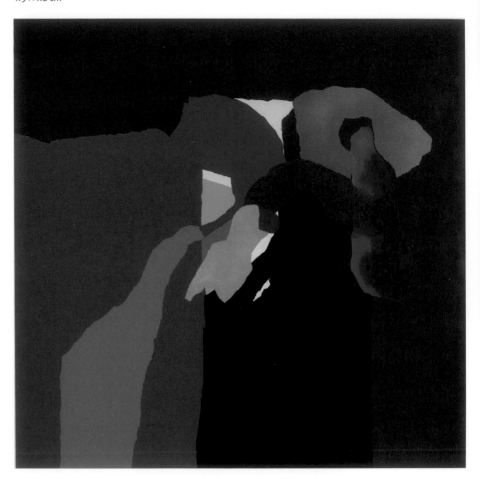

Albert Irvin RA
Blackfriars XVIII
screen woodblock and hand colouring
60 × 71 cm

Prof Clyde Hopkins
Plankhead
screenprint
52 × 57 cm

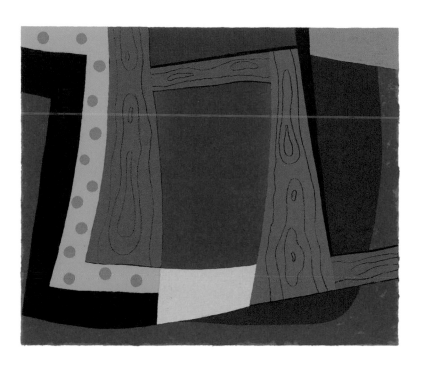

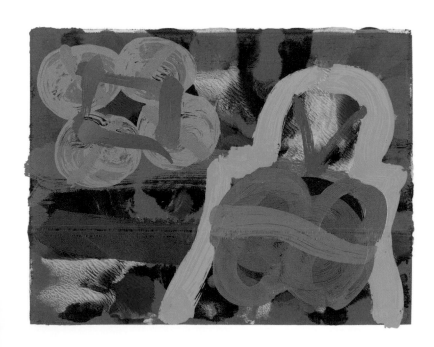

Ana Maria Pacheo
Dark Event VII
drypoint
86 × 78 cm

Ana Maria Pacheo
Dark Event III
drypoint
86 × 78 cm

Jane Dixon
Regeneration II (Chicago)
etching
41 × 59 cm

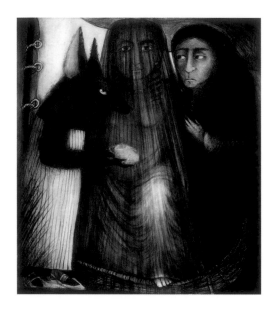

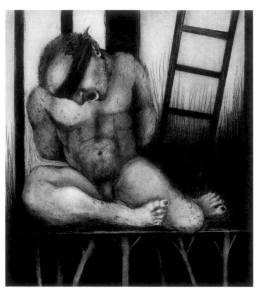

Kip Gresham
Henry
woodcut
100 × 58 cm

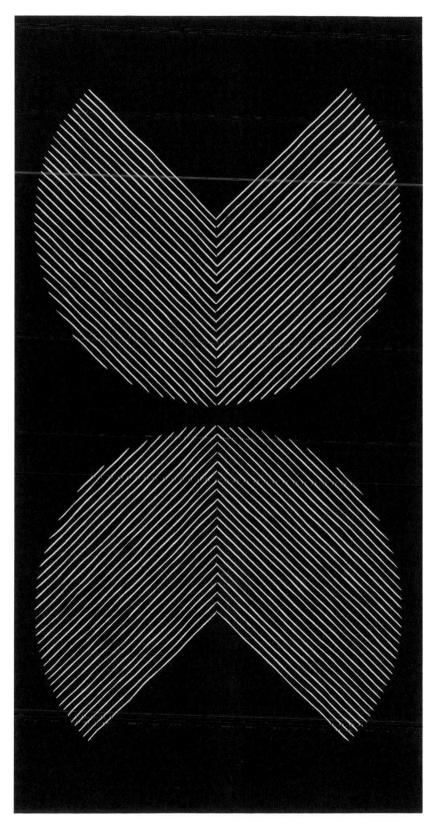

SMALL WESTON ROOM

Jean Cooke RA
Dream Dream
acrylic on canvas
50 × 50 cm

Simon Wright
Desk
oil on board
39 × 34 cm

Robert Dukes
Quince
oil on board
26 × 26 cm

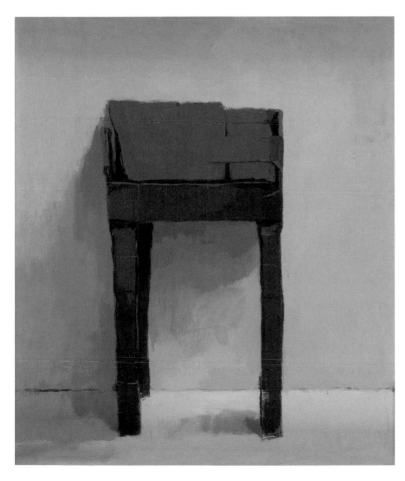

Charles Williams
The Lovers
oil on canvas
36 × 36 cm

Pádraig MacMiadhacháin
Strange Catch, Co Mayo
oil on linen canvas
42 × 47 cm

Mick Rooney RA
Small Incident in a Foreign Land
gouache and tempera on paper
37 × 29 cm

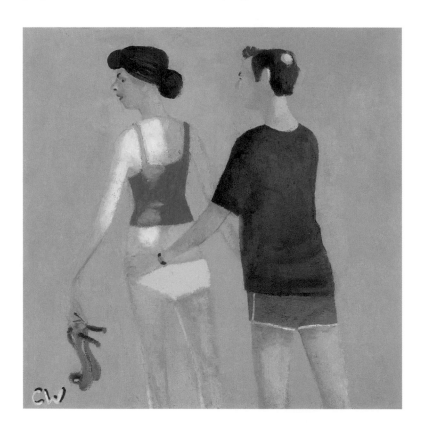

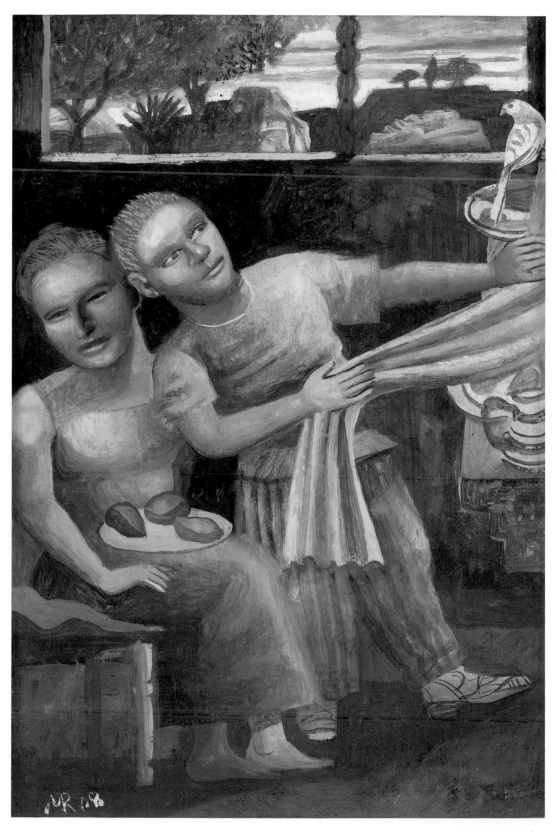

Matthew Kolakowski
Teenage, Dirtbag
oil on canvas
31 × 29 cm

Mark Roscoe
Core, After the Book of Kells
mixed media
48 × 48 cm

Leonard Rosoman OBE RA
New York, New York II
pen, ink and crayon
45 × 43 cm

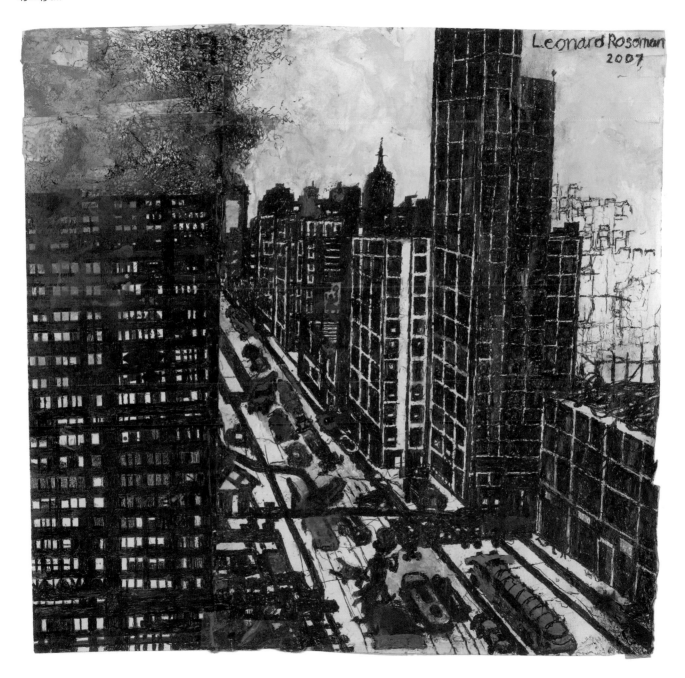

Mary Fedden OBE RA PPRWA
The Black Chair
oil on canvas
66 × 76 cm

Frederick Gore CBE RA
Nîmes: The Maison Carrée
oil on canvas
92 × 102 cm

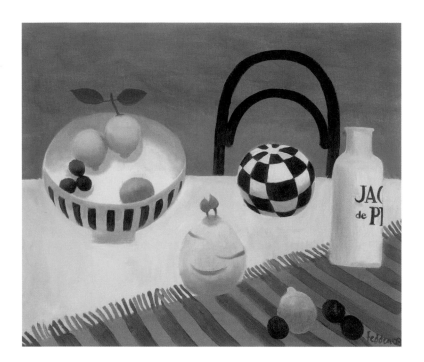

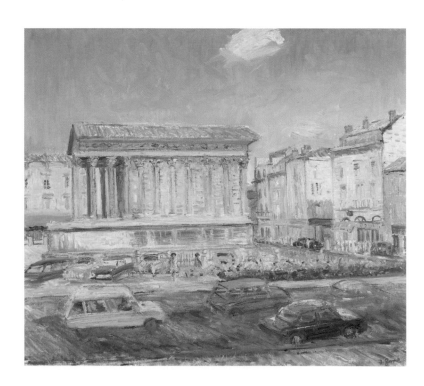

Bernard Dunstan RA PPRWA
Dressing, Winter Morning
oil
37 × 29 cm

Diana Armfield RA
Nasturtiums in High Summer
oil
40 × 34 cm

Christopher Jinks
Au Lapin Agile (Montmartre)
acrylic on canvas
13 × 18 cm

Covadonga Valdes
Casa Blanca, 6
oil on board
23 × 30 cm

Angela Conway
The Lighthouse
acrylic
53 × 74 cm

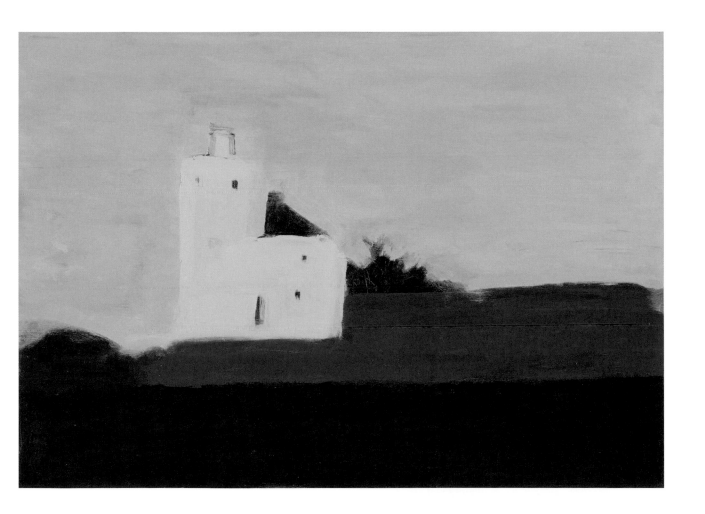

Nadia Hebson
Untitled
oil on zinc
47 × 38 cm

Andrew Ratcliffe
Charlotte
oil on canvas
69 × 59 cm

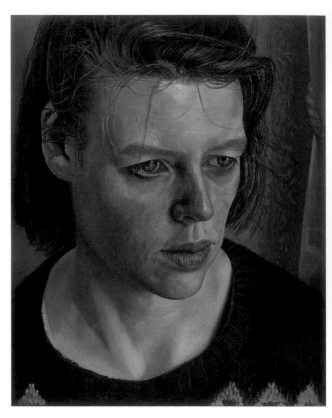

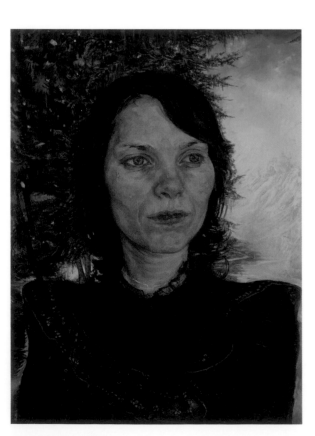

Tai-Shan Schierenberg
The Scot, 2007
oil on paper
37 × 37 cm

Tony Beaver
Found Boy
oil on canvas
70 × 61 cm

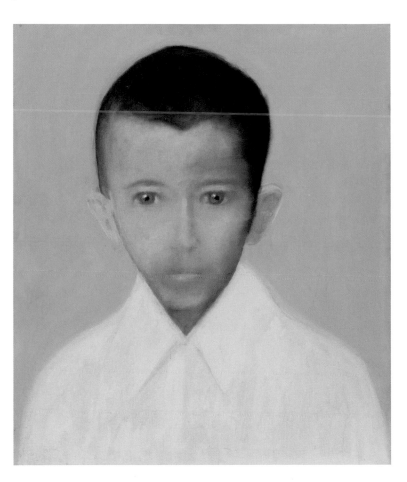

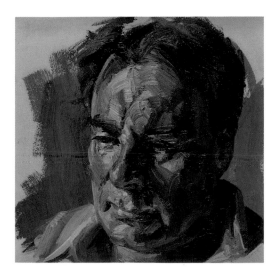

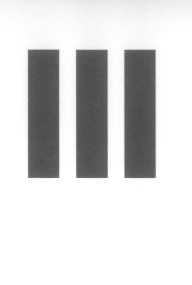

Adrian Berg RA
After Ravilious Night Crossing
oil on canvas
76 × 102 cm

Dr Barbara Rae CBE RA
Olive Terraces, Zahara
mixed media on paper
102 × 117 cm

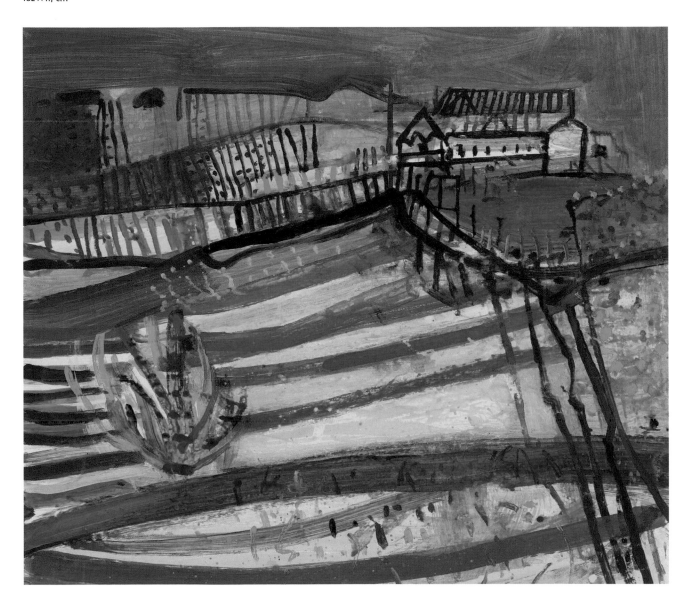

Jennifer Durrant RA
Rush (White and Purple)
acrylic on canvas on board
53 × 43 cm

Frank Bowling RA
Tranegone (Who's Afraid of Red, Yellow and Blue)
acrylic on canvas
225 × 190 cm

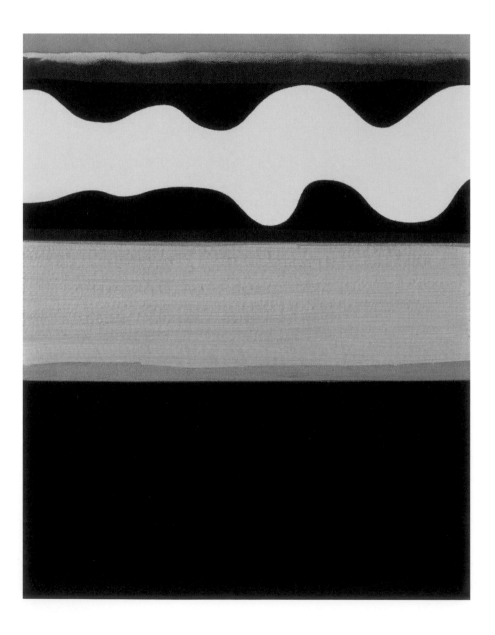

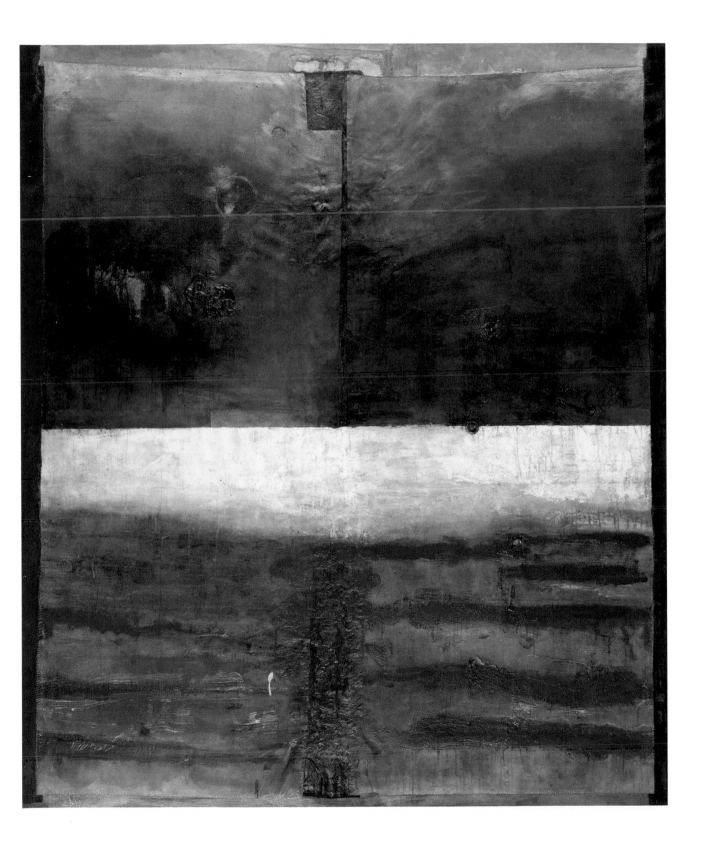

Tony Bevan RA
Head
acrylic and charcoal on canvas
267 × 297 cm

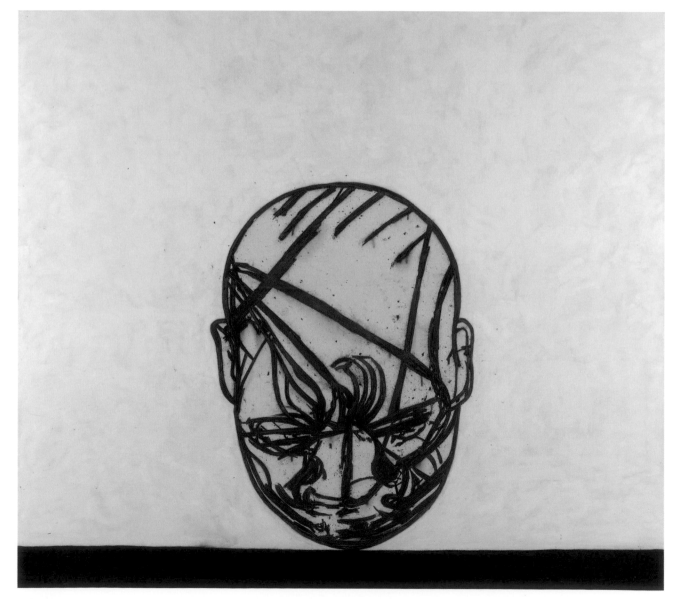

Anthony Whishaw RA
Downstream with fish, Eye, Hook, Tree and Birds
acrylic and collage on canvas
183 × 364 cm

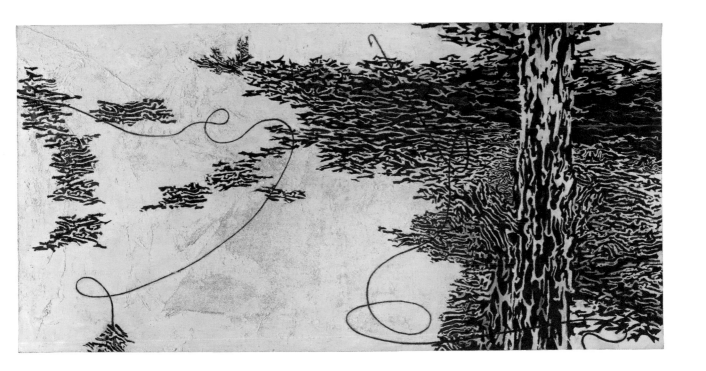

Prof Maurice Cockrill RA
Spring Song #1
ink and acrylic on paper
197 × 113 cm

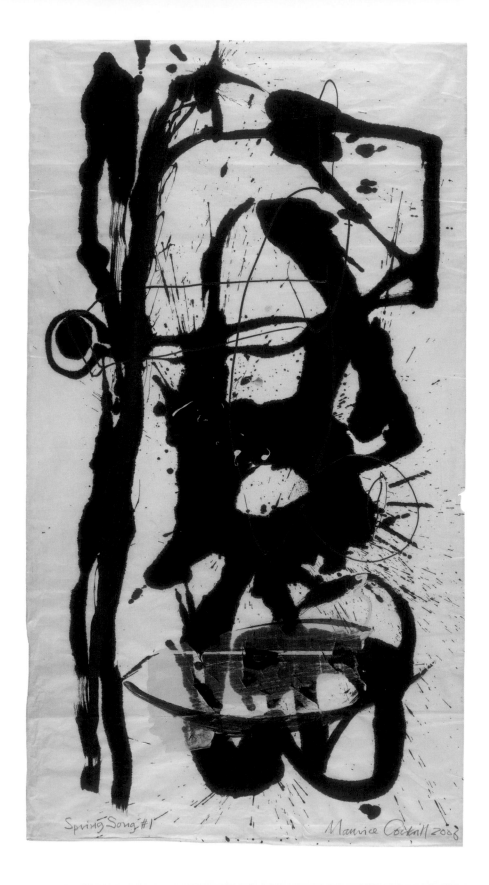

Flavia Irwin RA
Shadow Dance I
acrylic on canvas
129 × 92 cm

Stephen Chambers RA
Multistack
oil on canvas
190 × 249 cm

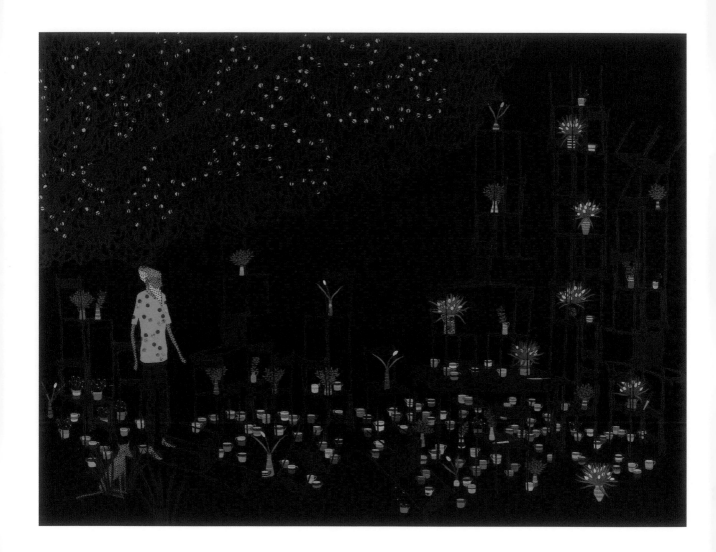

Prof Stephen Farthing RA
Sketch for a Big Painting in Four Parts
acrylic on canvas
400 × 230 cm

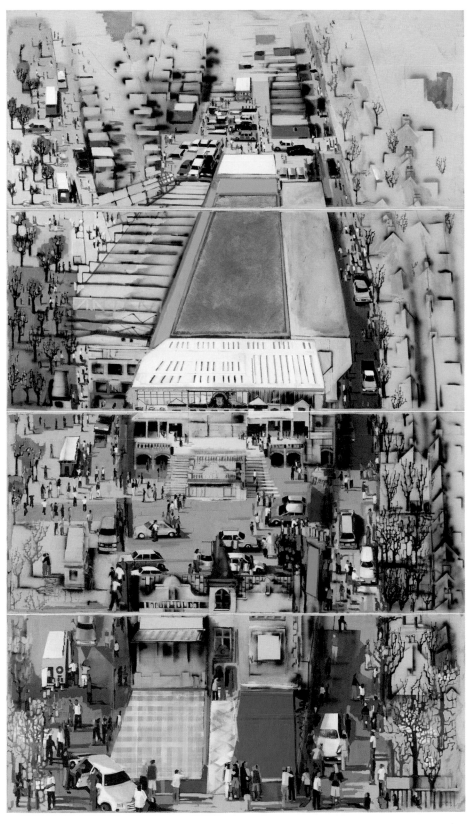

Bill Jacklin RA
Snow, Times Square II
oil on canvas
182 × 198 cm

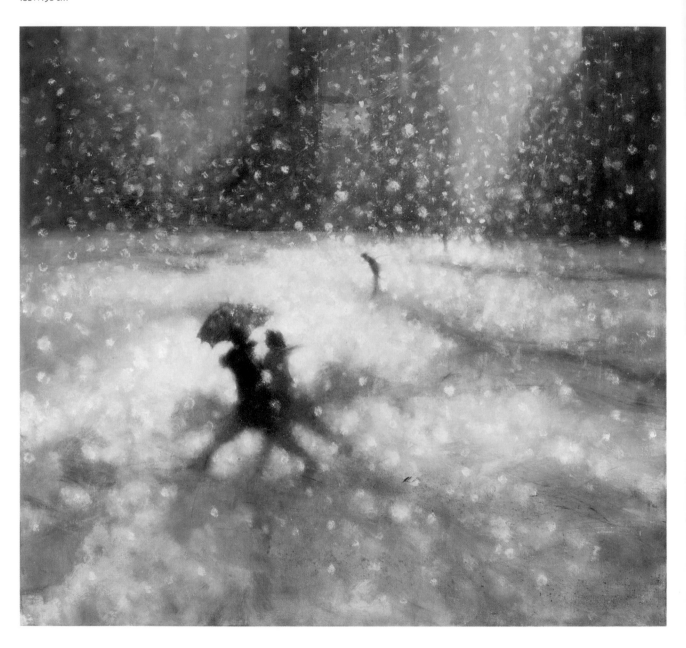

Sonia Lawson RA
Against the Sky, 42 Horses and Two Birds on an Easel
watercolour and acrylic on paper
134 × 109 cm

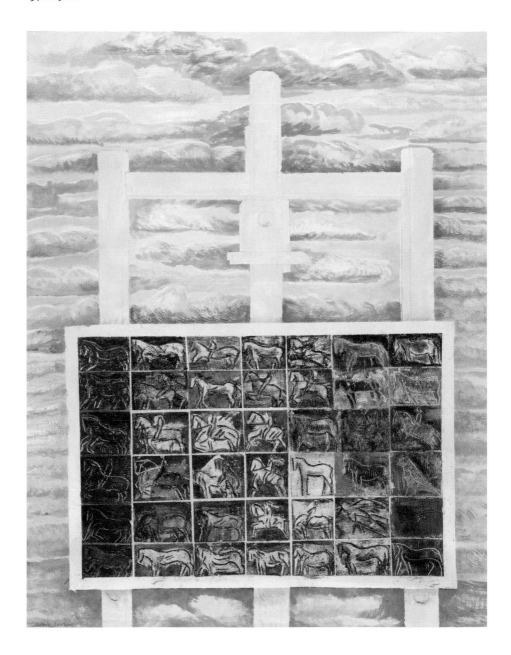

Lisa Milroy RA
Tuesday Afternoon
oil on canvas
374 × 534 cm

Michael Craig–Martin CBE RA
Death
acrylic on aluminium
200 × 325 cm

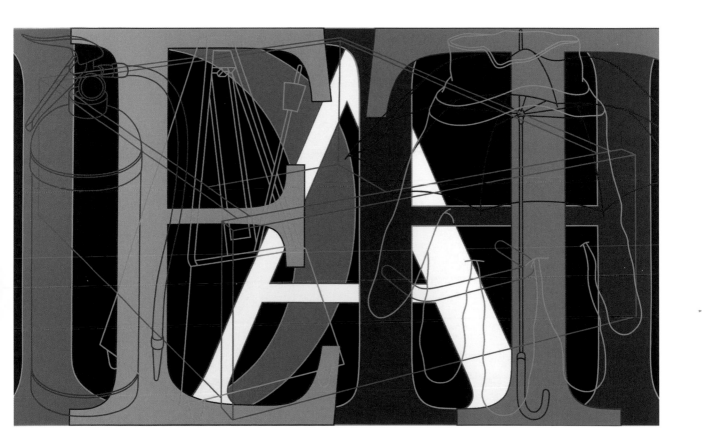

Christopher Le Brun RA
Tirra Lirra
oil on canvas
300 × 375 cm

Gus Cummins RA
Memories
acrylic on canvas
150 × 200 cm

Allen Jones RA
London Derrière
oil on canvas
164 × 119 cm

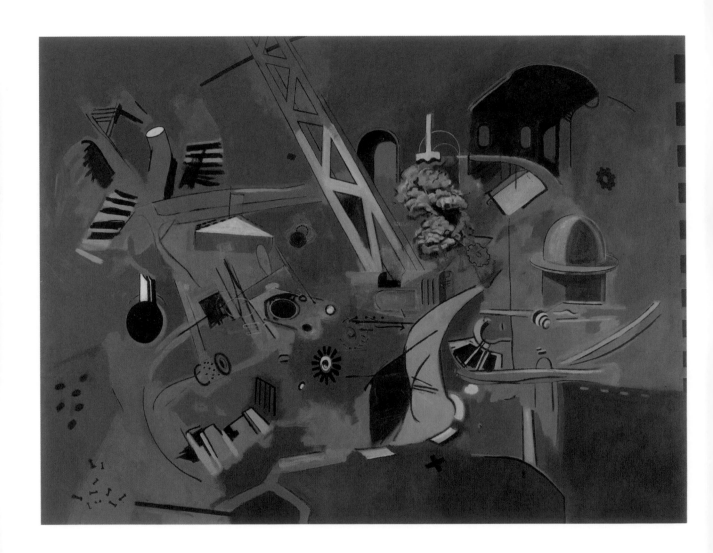

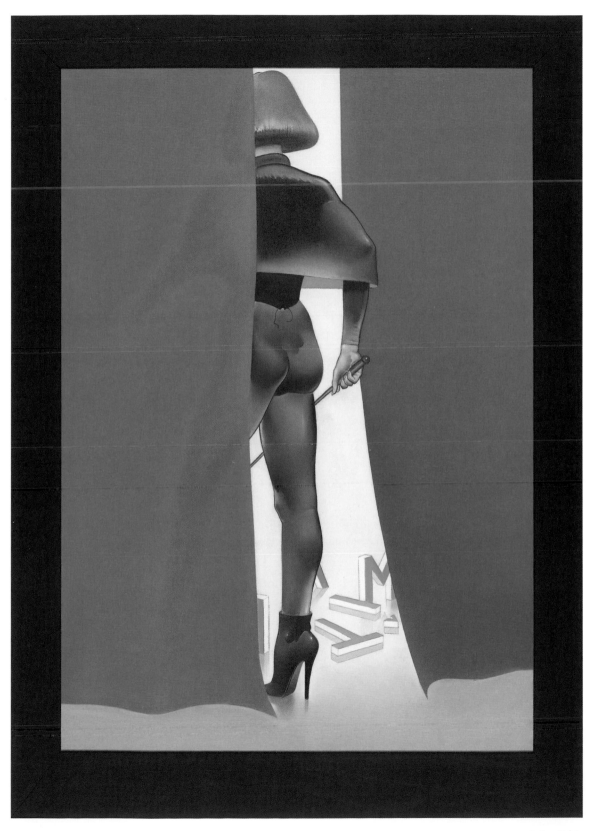

Mark Alexander
The Blacker Gachet XIII
oil on canvas
88 × 77 cm

Ben Ravenscroft
Untitled
acryllc on board
60 × 59 cm

Michael O'Mahony
Untitled
ink and watercolour
70 × 99 cm

Gabor Gyory
Low Clearance
oil on board
33 × 58 cm

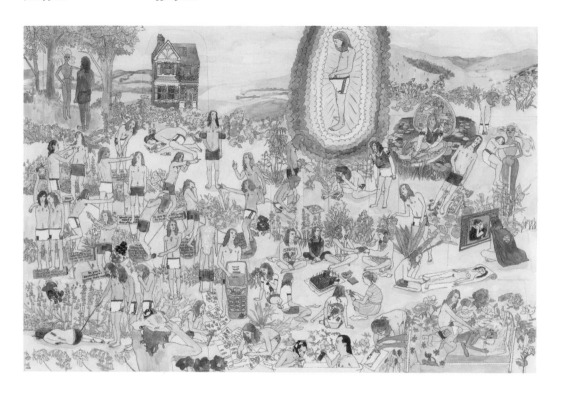

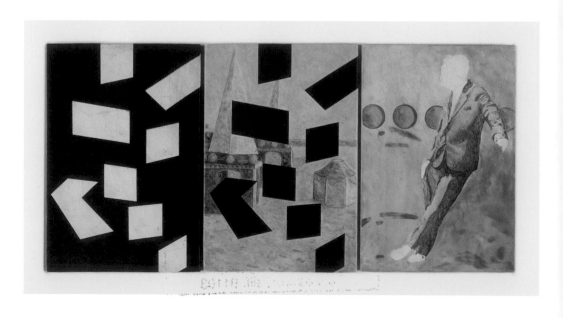

Christopher Page
Darfur!
oil and gloss paint on board
top: 17 × 60 cm
bottom: 55 × 40 cm

Jez Brann
Untitled (RhomBus)
mixed media
H 50 cm

Christopher Shilling
To be Confirmed (detail)
oil on board
24 × 18 cm

Geoffrey Rigden
Palassi #3
acrylic on canvas
82 × 42 cm

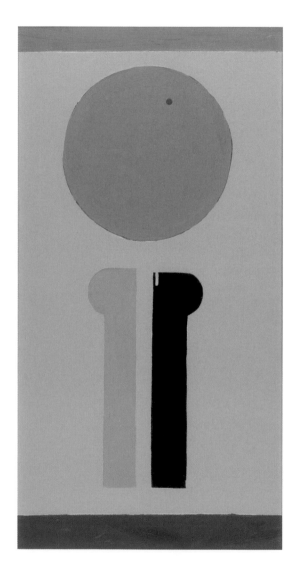

Humphrey Ocean RA
Morning
oil on canvas
80 × 99 cm

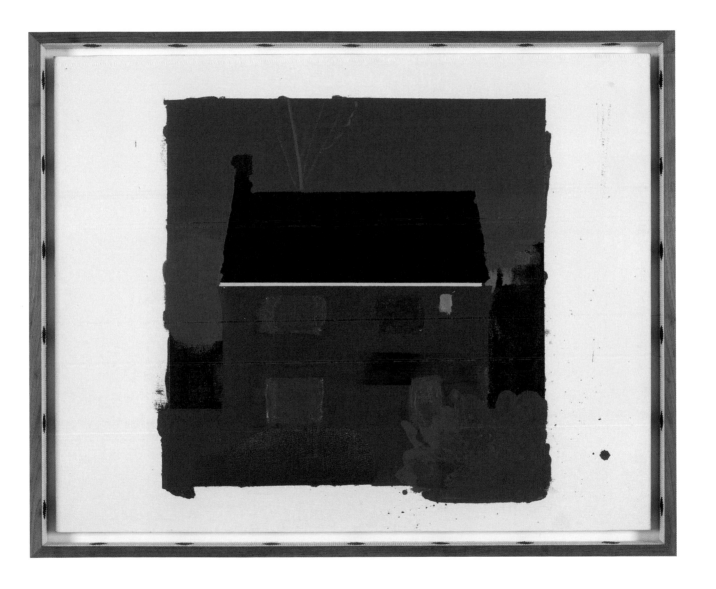

Mali Morris
Marron Glacé
acrylic on canvas
31 × 41 cm

Mark Francis
Collider
oil on canvas
101 × 84 cm

Laura Stocker
Untitled, Black & White 2
matchsticks
90 × 60 cm

Margaret Calvert
Woman at Work
acrylic on metal
175 × 86 cm

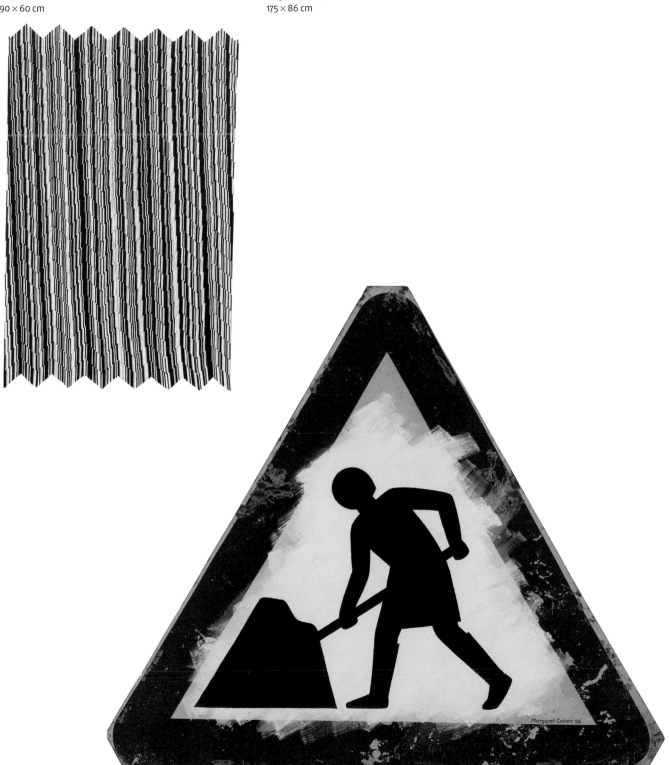

Noel Forster
Untitled
oil on linen
101×76 cm

Anselm Kiefer Hon RA
San Loretto
emulsion and acrylic on canvas
660×380 cm

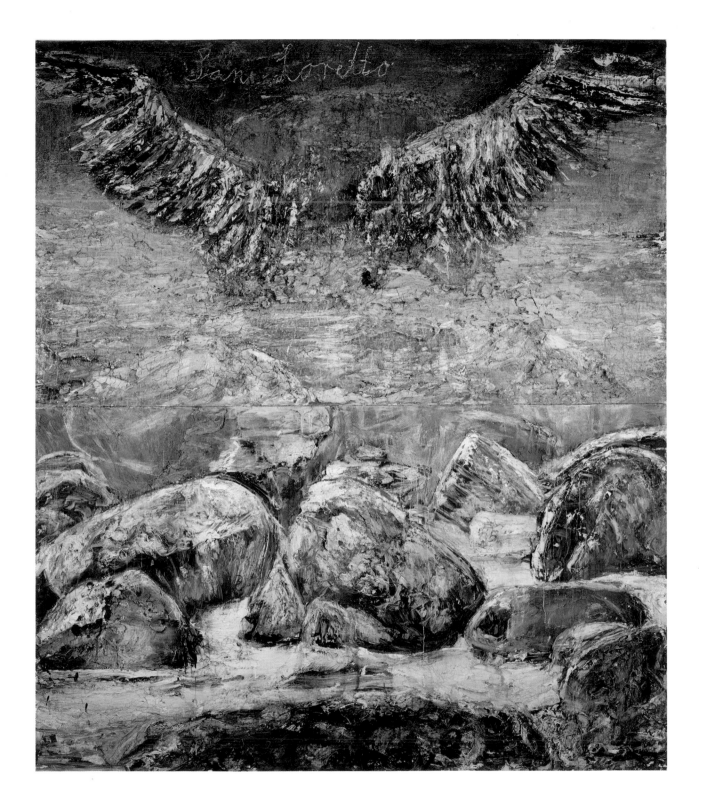

Jeffrey Dennis
Dispatch
oil on linen
100 × 80 cm

Paul Tonkin
Aftermath
acrylic on canvas
182 × 238 cm

Richard Kirwan
As Above, So Below
giclée, silkscreen varnish on paper
50 × 50 cm

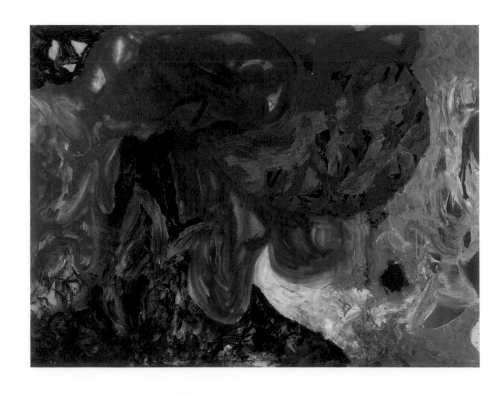

Gillian Ayres OBE RA
Lapis Lazuli that in the Channel Flows
oil on canvas
198 × 274 cm

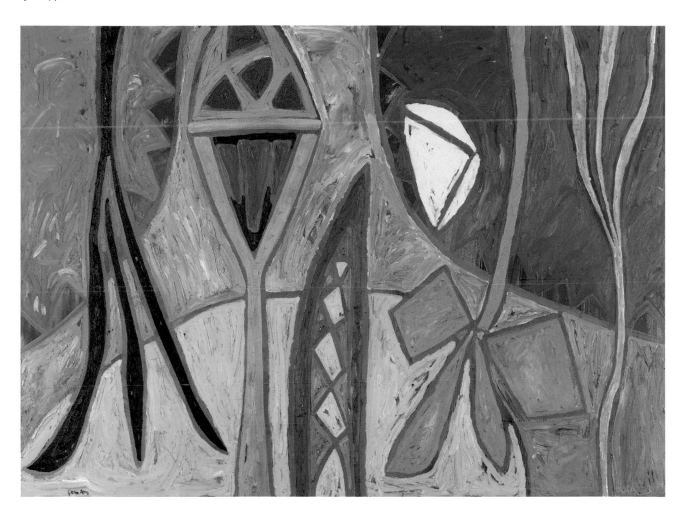

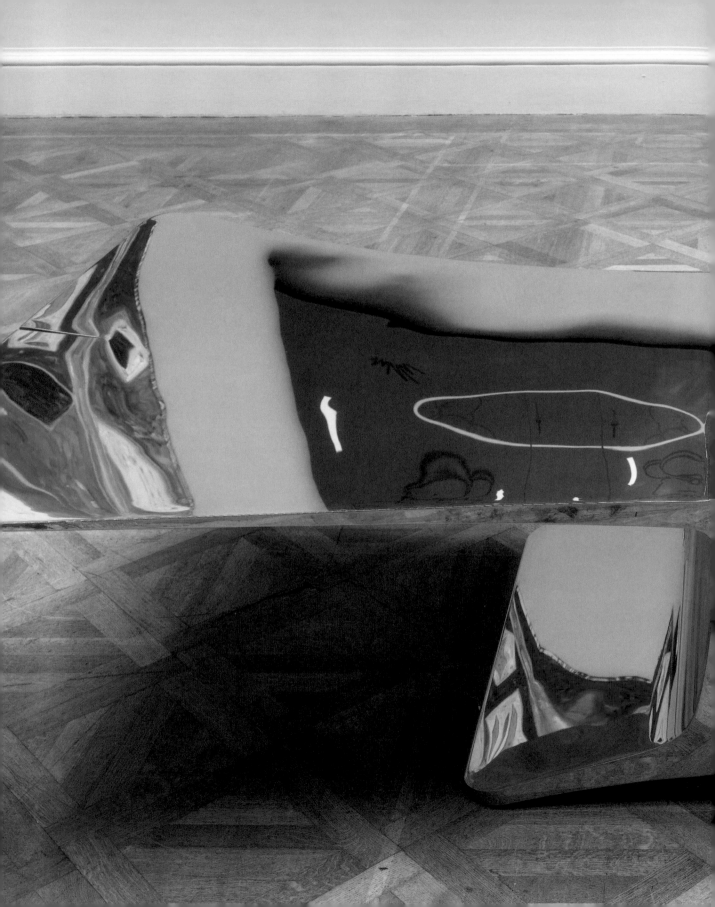

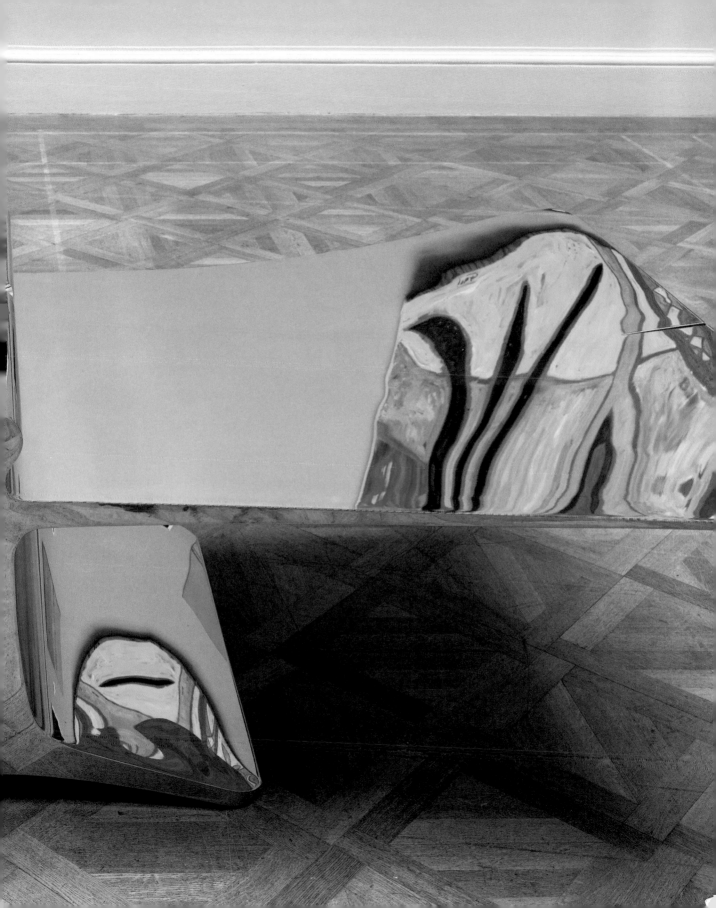

Jane Morgan
Gilly
photographic print
136 × 109 cm

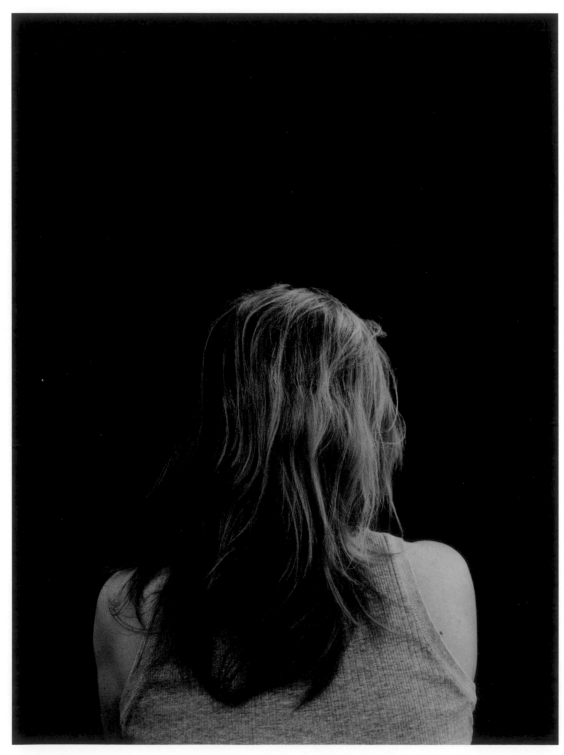

Florin–Catalin Ungureanu
CCTV
acrylic on board
H 35 cm

Paul Winstanley
White House
oil on linen
50 × 66 cm

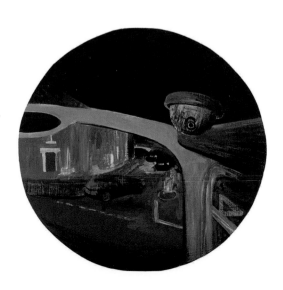

Gerard Hemsworth
The Futility of Rivalry
acrylic on canvas
213 × 244 cm

Jock McFadyen
QE2 Bridge
oil on canvas
102 × 79 cm

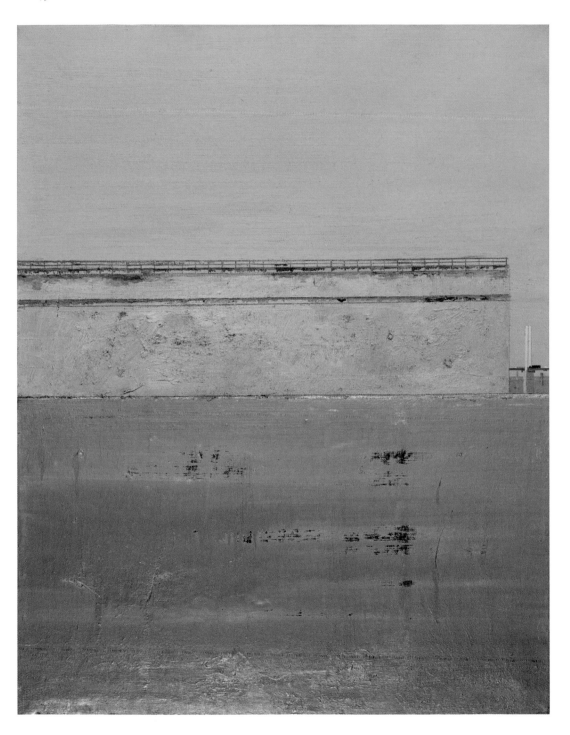

Sophy Dury
Juliet, Funky Cardigan
painted terracotta
H 22 cm

Clive Barker
Jelly Bean Machine No 2
bronze
H 32 cm

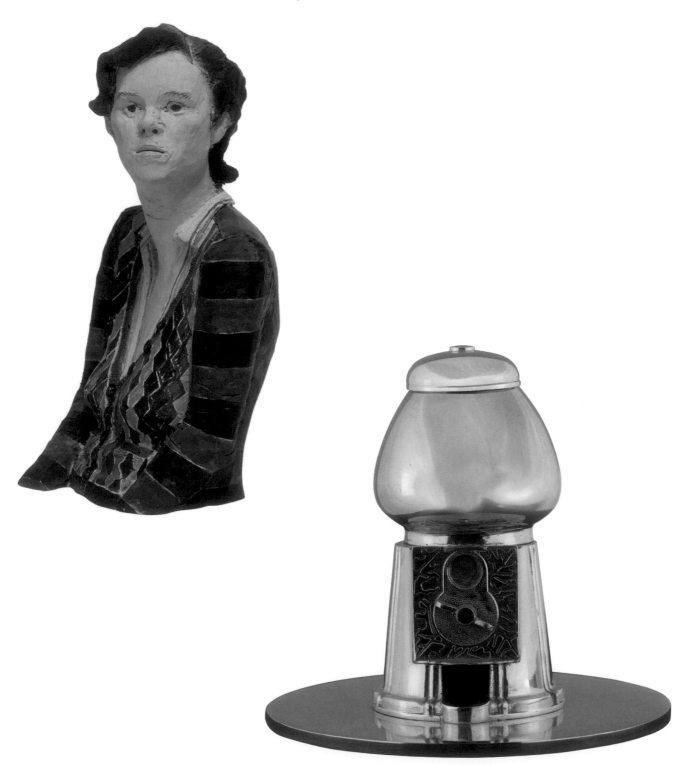

Emer O'Brien
Storm London
c–type print
48 × 30 cm

Nadia Hebson
Untitled
oil on canvas
140 × 150 cm

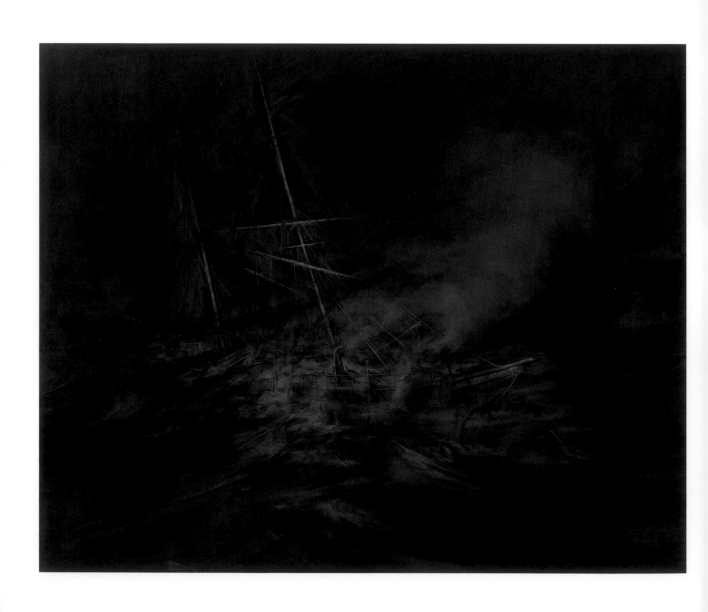

Frederick Cuming RA
February Clouds Camber
oil on canvas
140 × 140 cm

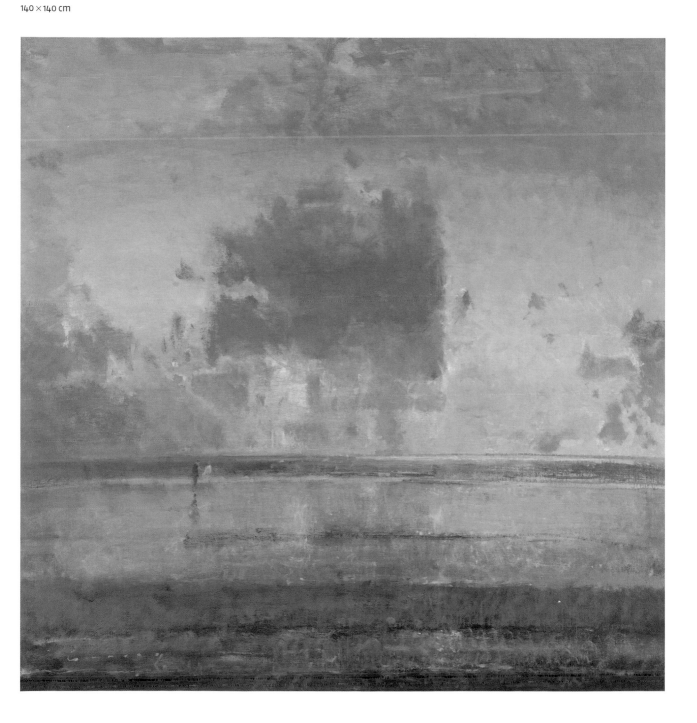

Jackie Nicholls
Order of Things
oil and acrylic on canvas
105 × 148 cm

Alex Ramsay
Night Vision
mixed media
173 × 173 cm

Gabriel Hartley
Tortoise Shell
mixed media on canvas
270 × 200 cm

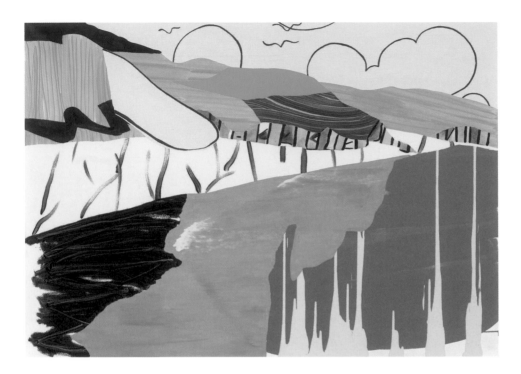

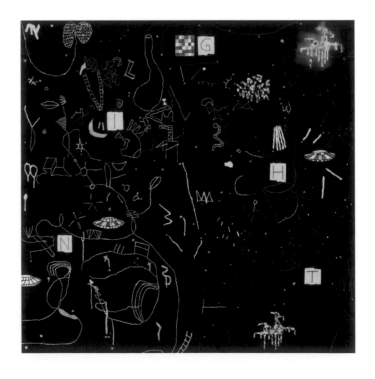

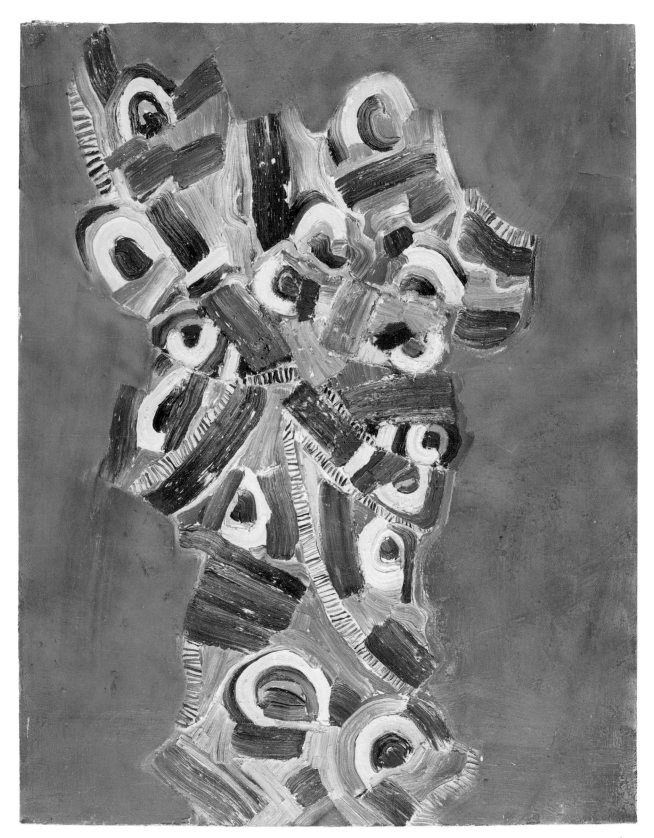

Gijs Pape
Dam # 1
spray paint on panel
36 × 123 cm

Jay Battle
Red‑spotted Pinstripe
marble and resin
H 30 cm

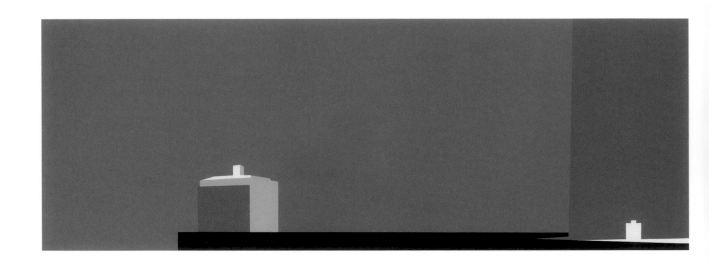

John Holden
Castle XXI
acrylic on canvas
183 × 183 cm

VI

Zaha Hadid CBE RA
Design for Proposed Museum in Vilnius, Lithuania
computer–rendered image

Chris Wilkinson OBE RA
Singapore Gardens by the Bay
model
H 41 cm

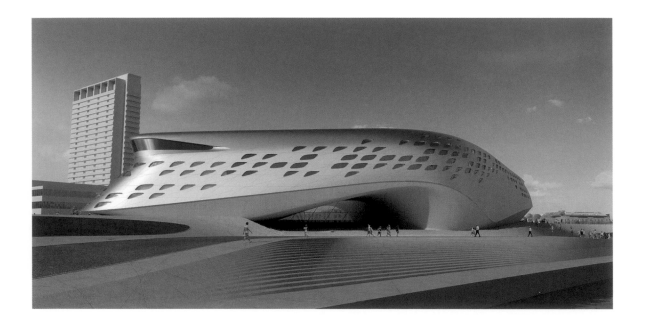

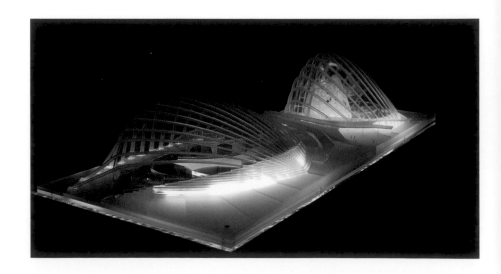

Sir Michael Hopkins CBE RA
London 2012 Olympic VeloPark
model
H 18 cm

Lord Foster of Thames Bank OM RA
Model of Camp Nou Stadium, Home of FC Barcelona
model
H 17 cm

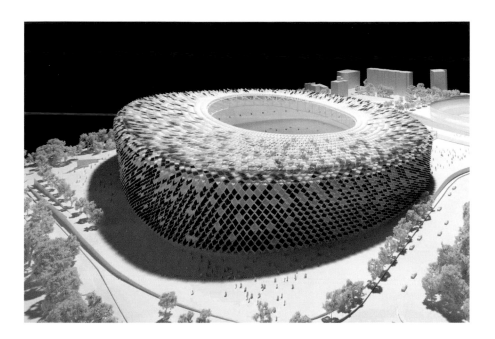

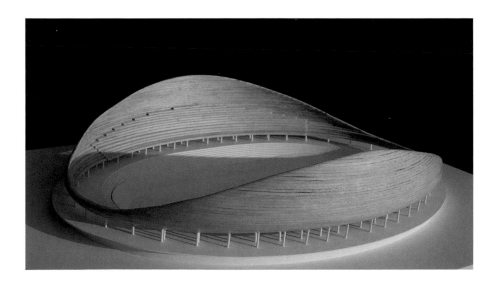

Hélène Binet
Zaragoza Bridge Pavilion (detail)
photographic print
86 × 210 cm

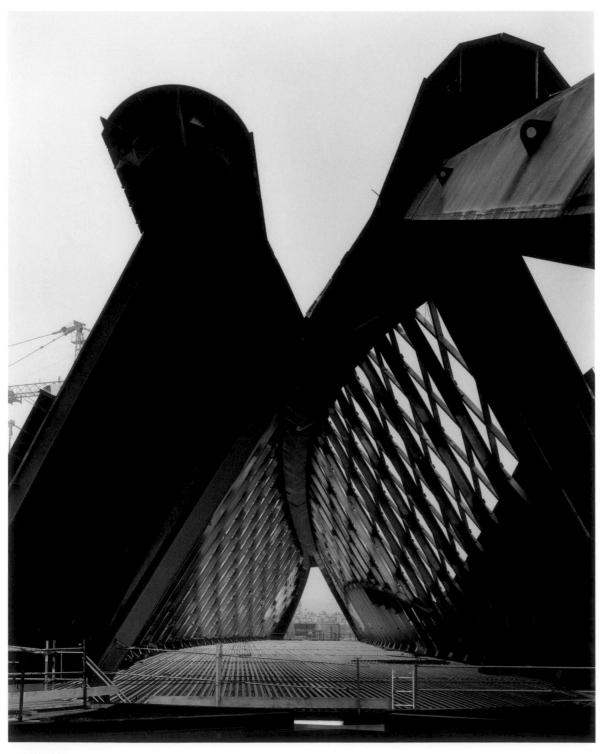

Eva Jiricna CBE RA
Pedestrian Bridge, Ostrava, Czech Republic
(detail)
photographic transparency
69 × 94 cm

Lord Rogers of Riverside RA
Metropolitana Linea 1, Santa Maria del Pianto, Naples, Italy (detail)
photographic print
84 × 59 cm

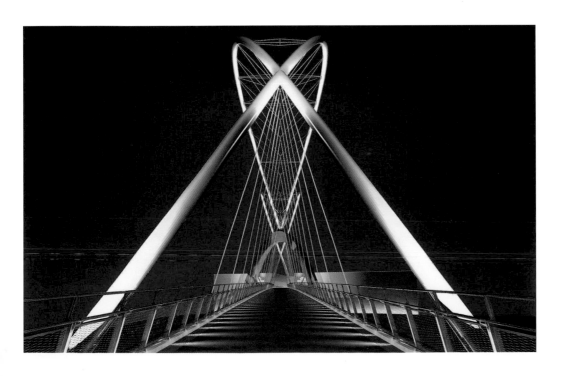

Prof Trevor Dannatt RA
Proposed House, Terwick Wood, West Sussex
Approved Scheme (detail)
model
H 24 cm

Prof Gordon Benson OBE RA
Land Made 2
laser print
18 × 39 cm

Jenny Lowe
Park Bench Becoming National Memorial
(detail)
inkjet prints and rapid prototyped model
43 × 92 cm

Prof Sir Peter Cook RA
Verbania Theatre, Massing Studies (detail)
digital print
80 × 60 cm

Prof Ian Ritchie CBE RA
Pearl of Dubai
etching
41 × 49 cm

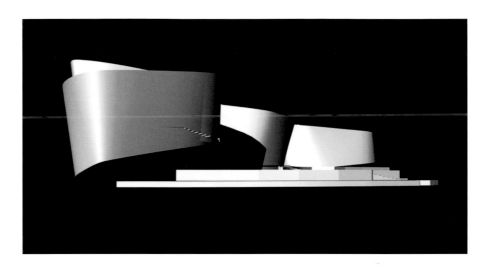

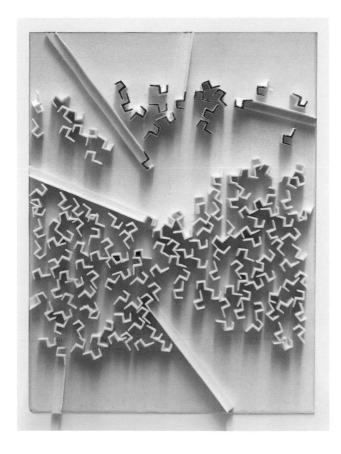

Paul Koralek CBE RA
House in Wicklow, Ireland
print
46 × 135 cm

Sir Richard MacCormac CBE RA
New Apartments, Jersey
digital print
54 × 104 cm

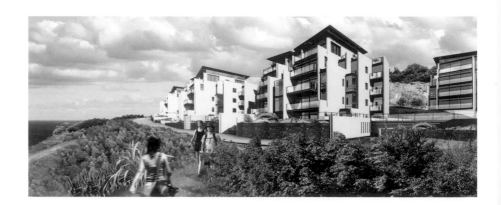

Michael Manser CBE RA
Hilton Hotel, Wembley. Sectional Model of Entrance Lobby and Restaurant
(detail)
model
H 30 cm

Eric Parry RA
Renewal of the Holburne Museum, Bath (detail)
model
H 26 cm

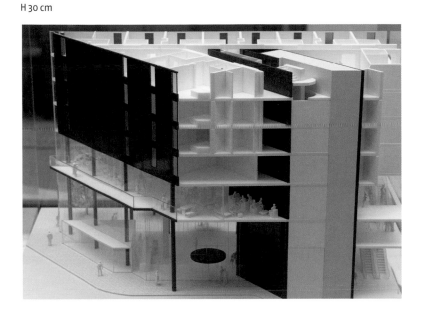

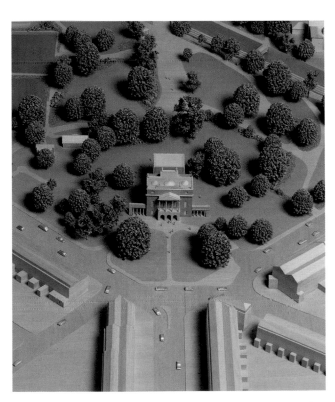

Peter L Wilson
Royal Academy Triptych, 3 Horizons (detail)
mixed media on wood
31 × 95 cm

Prof William Alsop OBE RA
House Work
mixed media
H 60 cm

Leonard Manasseh OBE RA PPRWA
Abstracted Bird-Head
coloured ink
34 × 44 cm

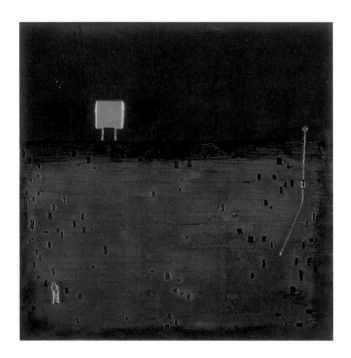

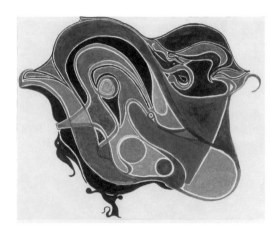

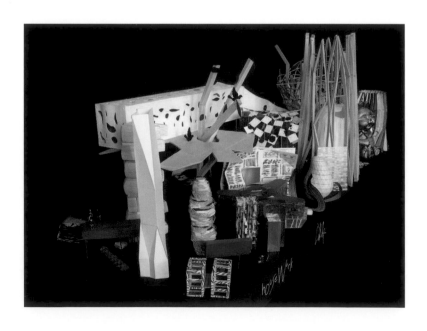

Edward Cullinan CBE RA
St John's College School: Partially Inhabited
print
71 × 92 cm

David Chipperfield CBE RA
Model of the Hepworth Wakefield
stone
H 12 cm

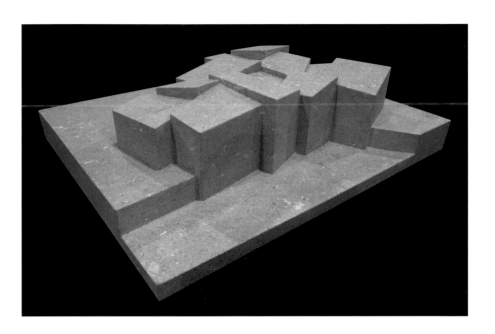

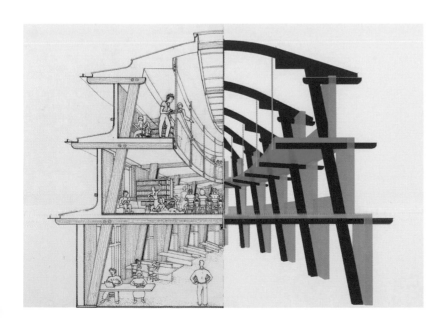

VII

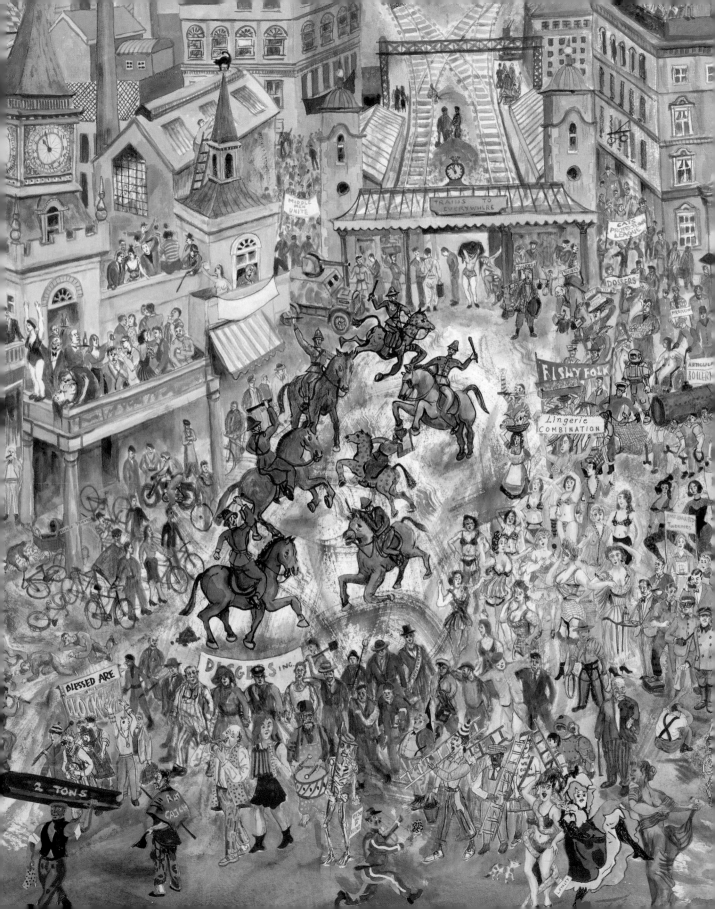

Philip Sutton RA
Wings of an Eagle
oil on canvas
88 × 89 cm

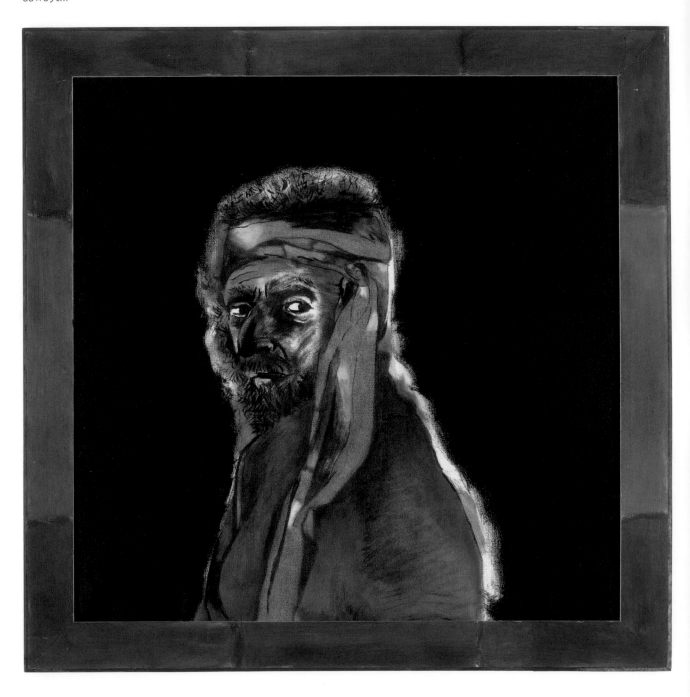

Dr John Bellany CBE HRSA RA
The Fisher Family
oil on canvas
152 × 152 cm

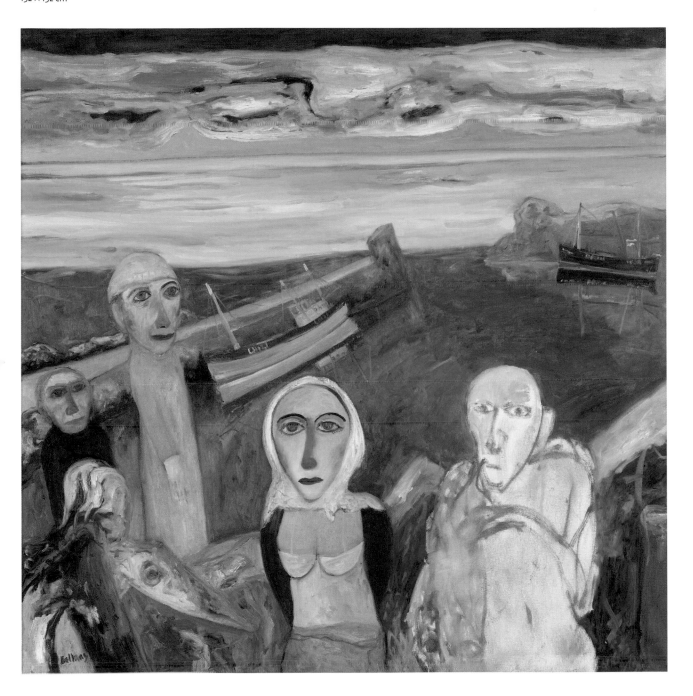

David Remfry MBE RA
Turning Burlesque Dancer (detail)
watercolour and graphite on paper
161 × 41 cm

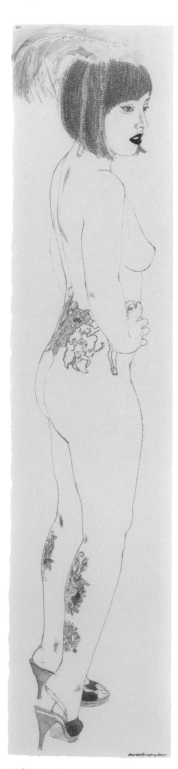

Dame Elizabeth Blackadder DBE RA
Pheasant
watercolour
84 × 107 cm

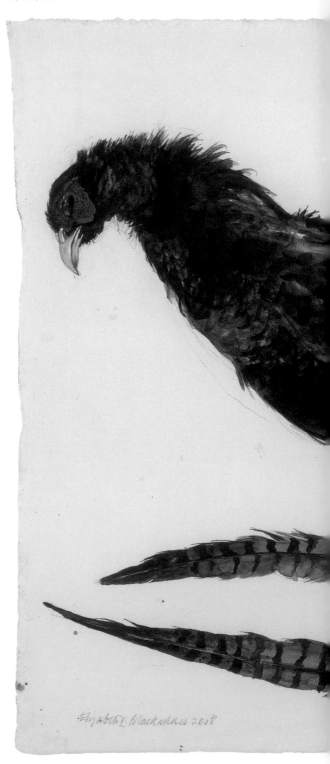

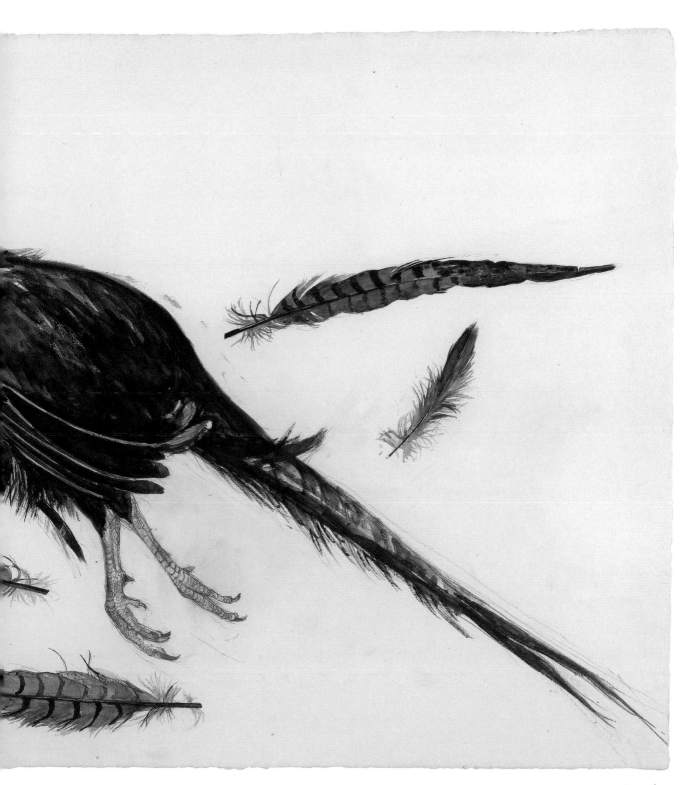

Ed Kevill-Davies
The Bouchiers
c-type print
112 × 125 cm

Gillian Wearing RA
Nancy Gregory
video still

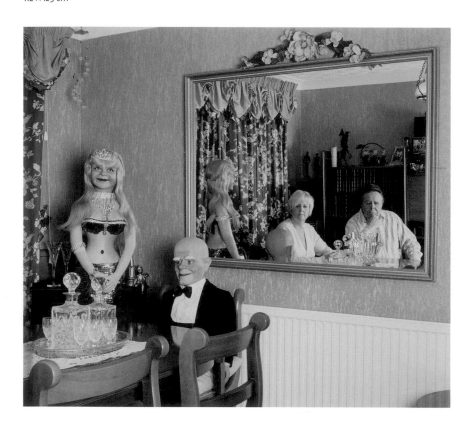

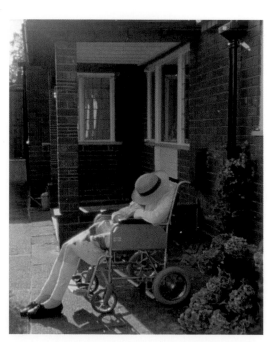

David Stewart
Girl 1
photographic print
164 × 123 cm

Simon Roberts
Abandoned Warship In Kola Bay, Murmansk, Russia
c-type print
85 × 100 cm

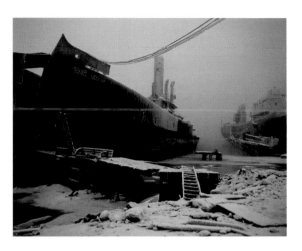

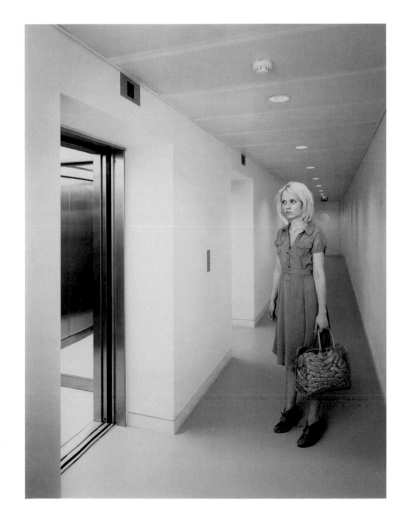

Prof Chris Orr RA
General Strike, or a Good Day Out
pencil, watercolour and ink
133 × 155 cm

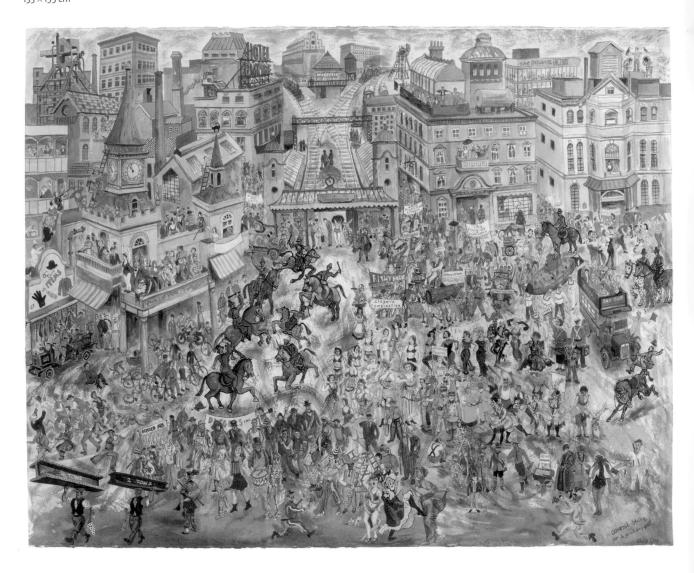

Michael Kidner RA
Particle Evolution: The End of the Tunnel at Cern. Stage 1
coloured pencil on paper
117 × 176 cm

John Wragg RA
Nocturne
acrylic on canvas
53 × 36 cm

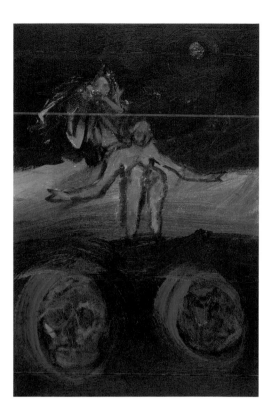

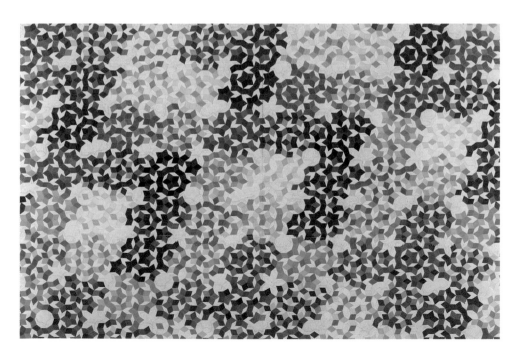

VIII

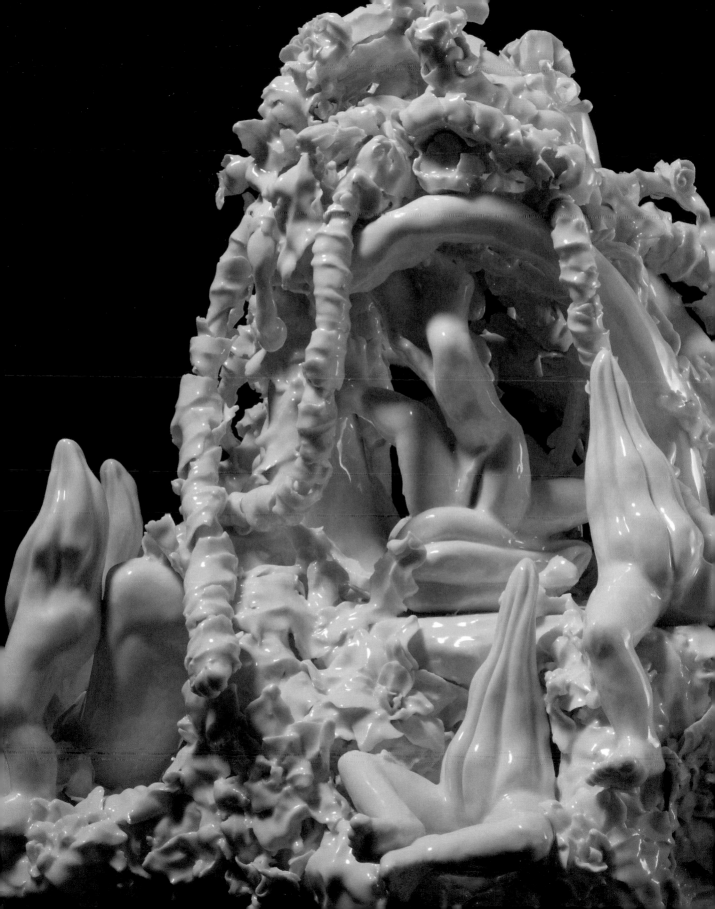

Gary Hume RA
To Be Confirmed
paint on paper
232 × 150 cm

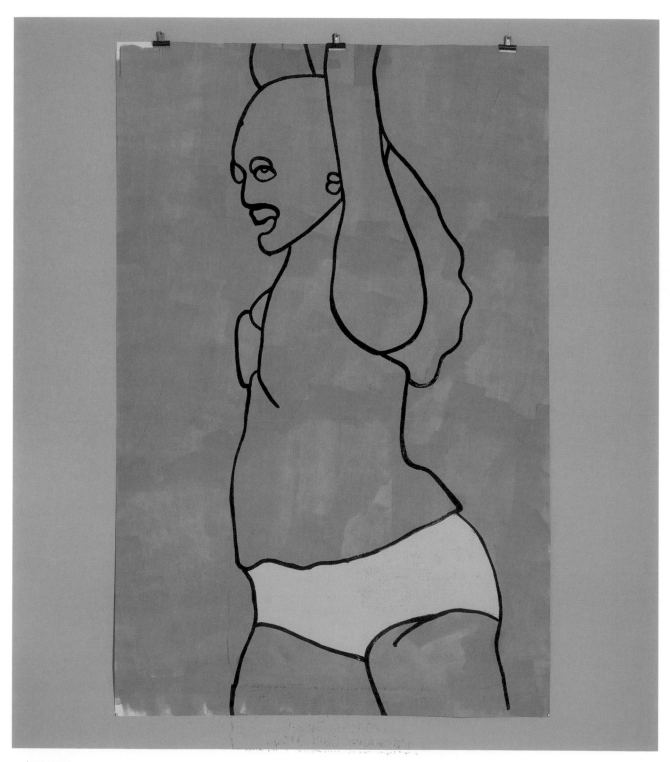

Tracey Emin RA
Ruined
acrylic, oil pastel and pencil on canvas
184 × 184 cm

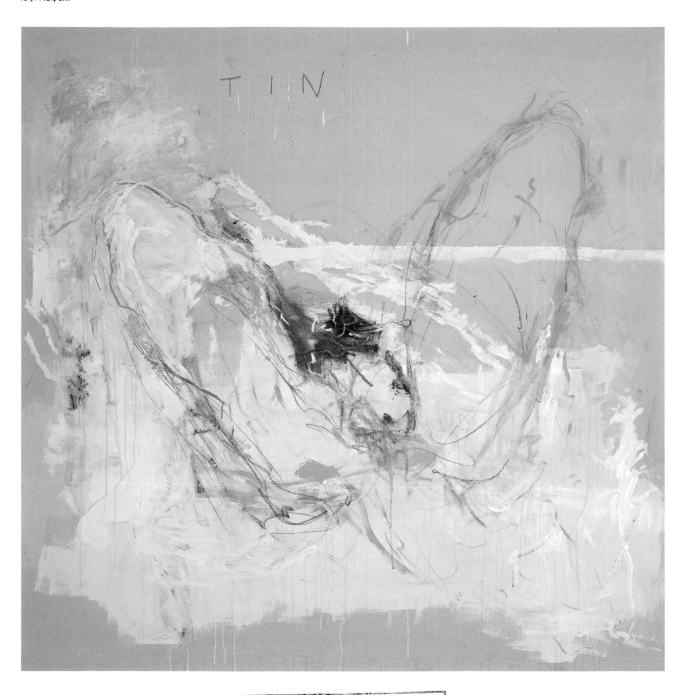

Vincent Hawkins
Last
acrylic on canvas
56 × 46 cm

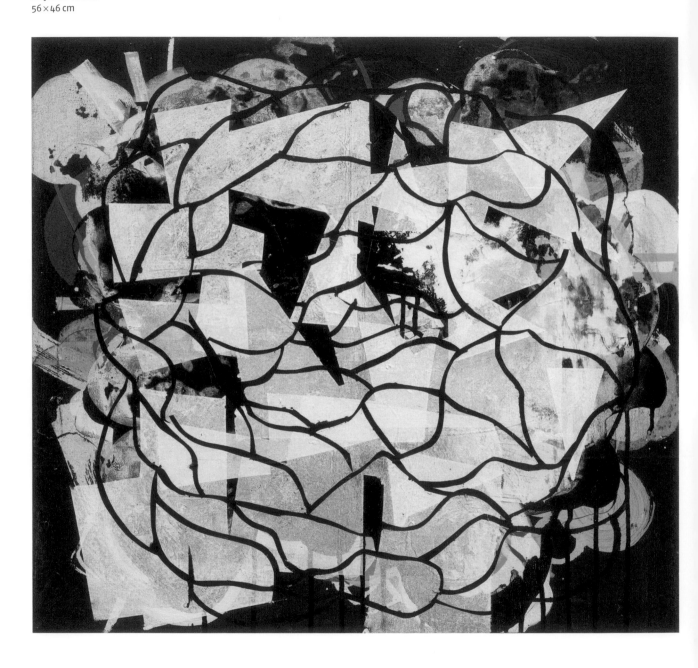

Tim Noble and Sue Webster
Pink Narcissus
mixed media
H 31 cm

Shaun Gladwell
Storm Sequence
video still

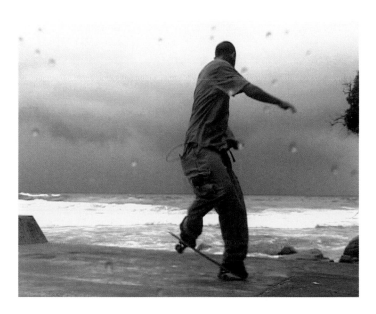

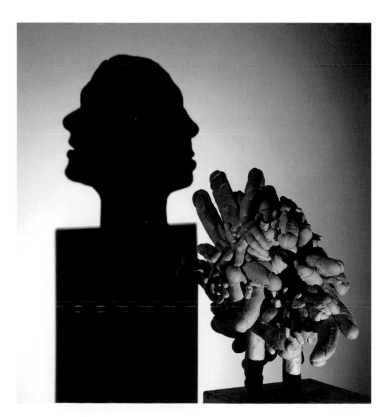

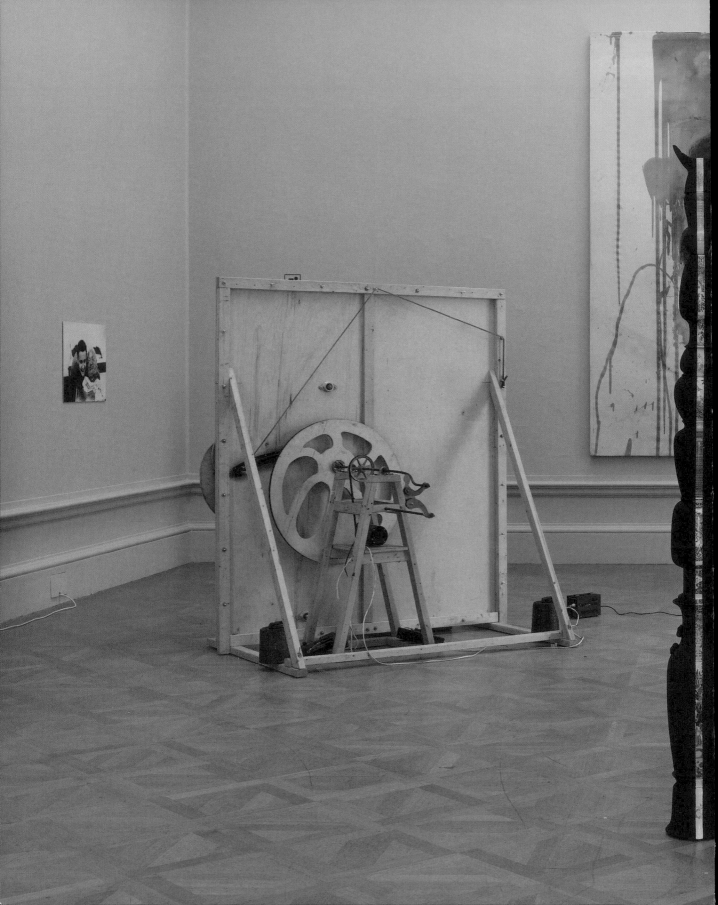

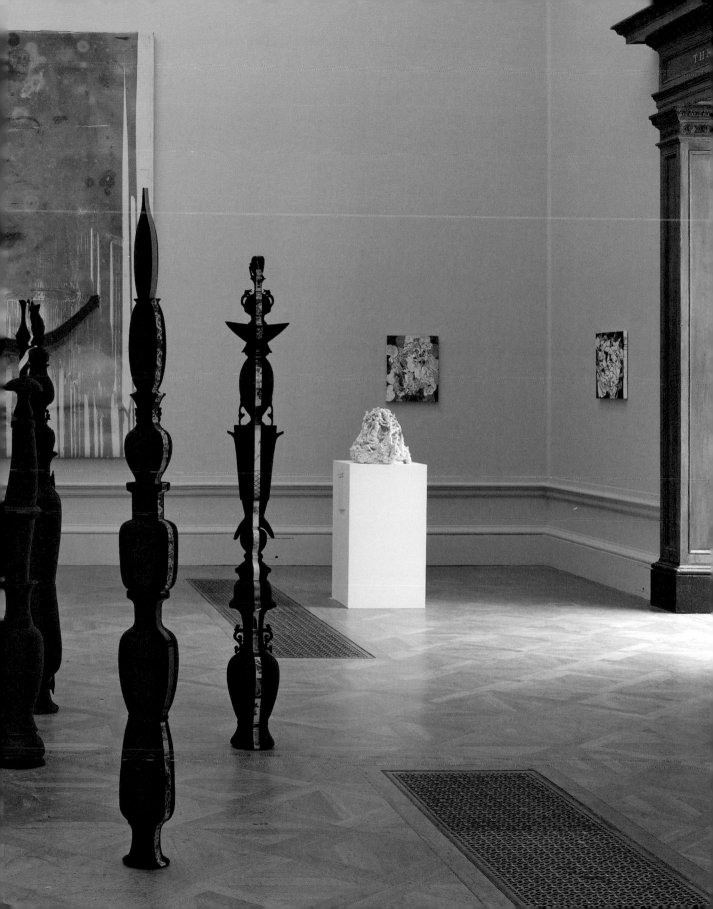

Louise Bourgeois
Untitled
painted bronze and steel
H 91 cm

Rachel Kneebone
In the Midst of Quietness Branched Thoughts Murmur
porcelain
H 50 cm

Julian Schnabel
Untitled (Japanese Girl)
mixed media
361 × 279 cm

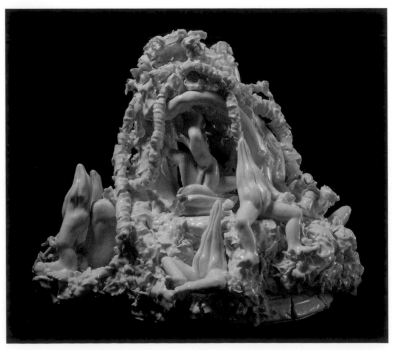

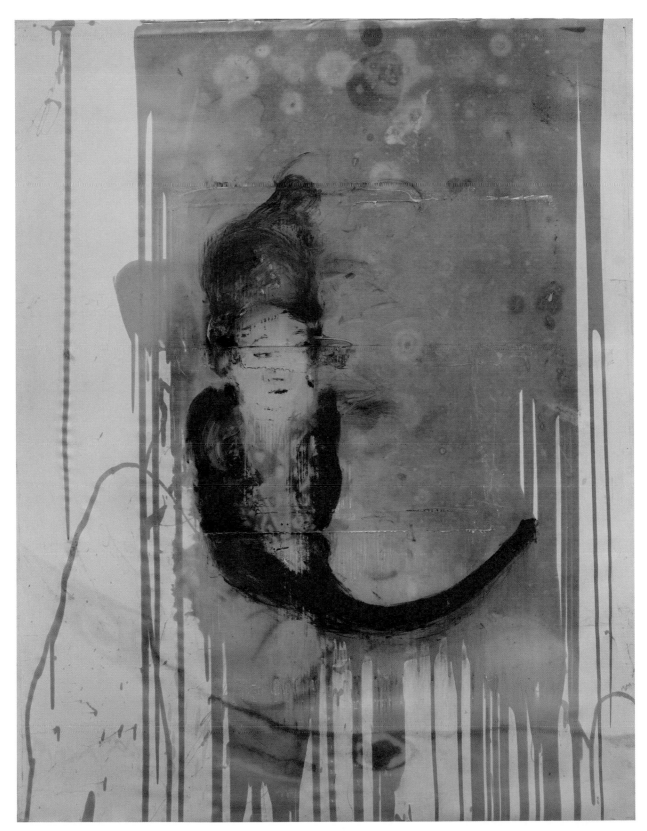

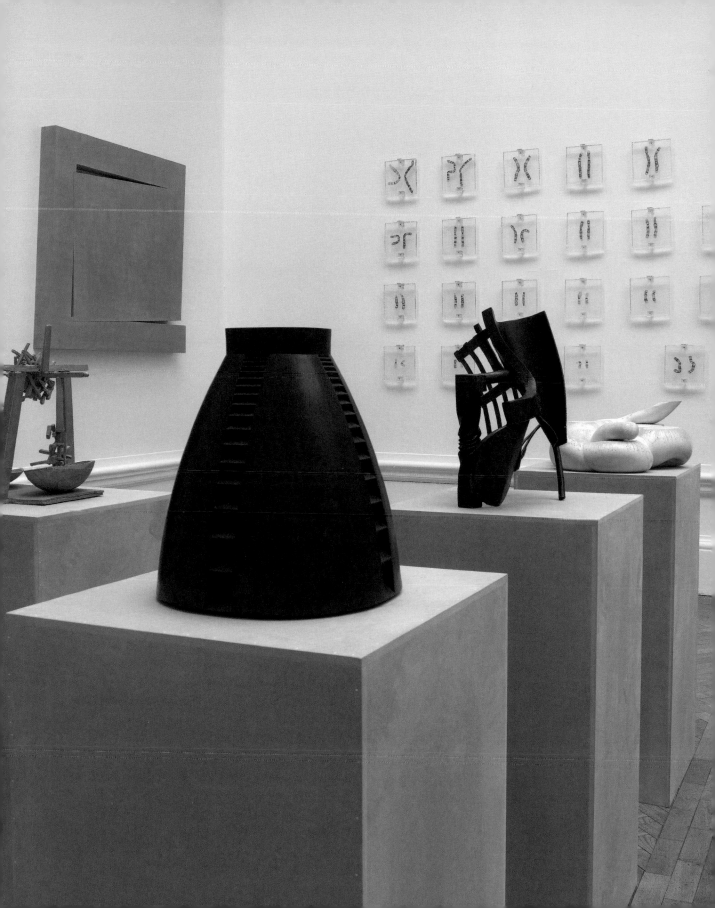

John Maine RA
Solid State 2
stone
H 76 cm

Richard Wilson RA
Turning the Place Over
inkjet on paper
109 × 104 cm

Nigel Hall RA
Drawing 1369
gouache and charcoal on paper
82 × 64 cm

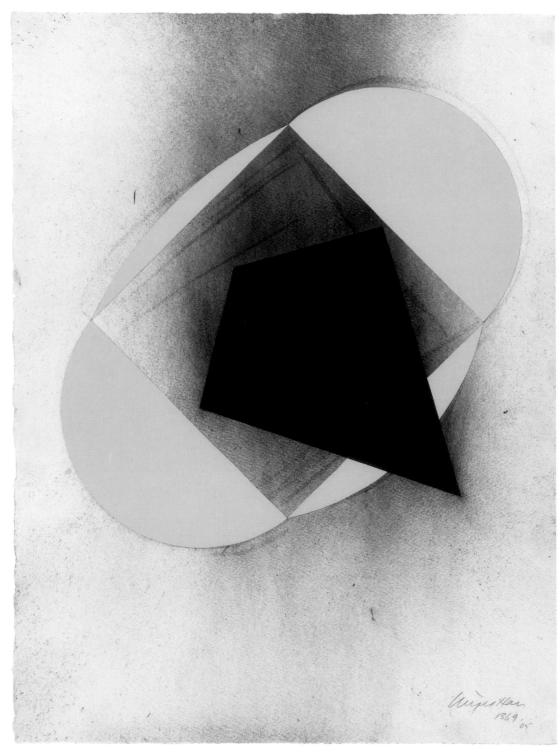

John Carter RA
Three Turns: Overlapping
mixed media
122 × 129 cm

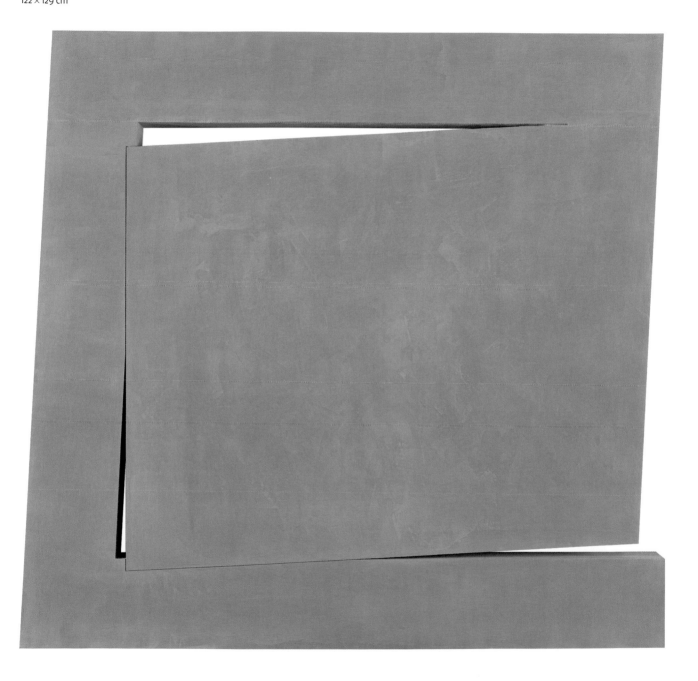

Prof Dhruva Mistry CBE RA
Spatial Diagram 05
painted steel
H 31 cm

Geoffrey Clarke RA
Against Nature
cast aluminium
H 41 cm

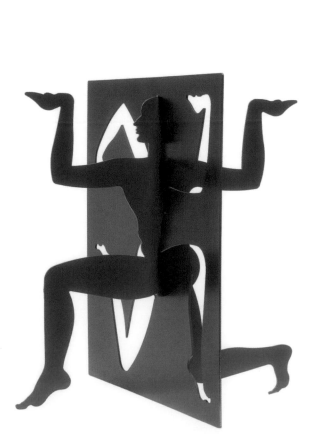

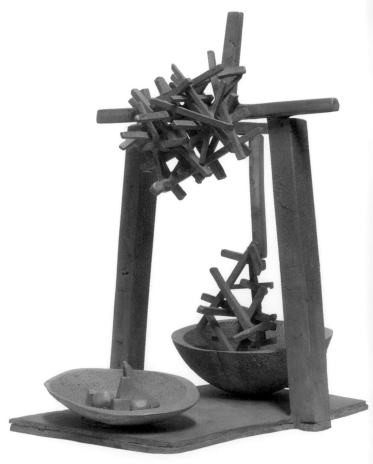

Ralph Brown RA
Female Head (Pomona)
bronze
H 25 cm

Ivor Abrahams RA
Tudor Totem
bronze
H 50 cm

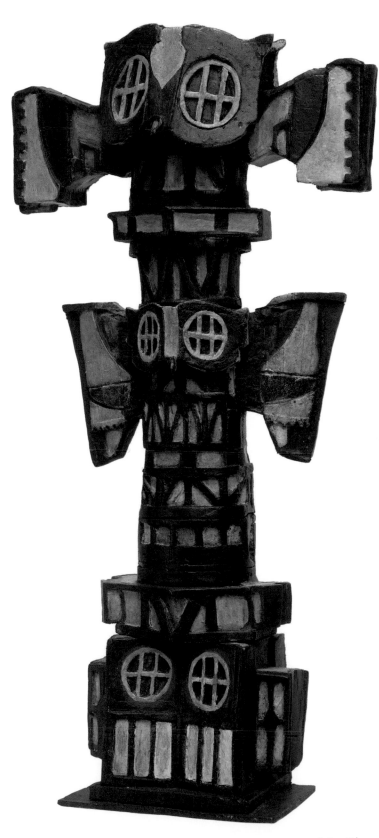

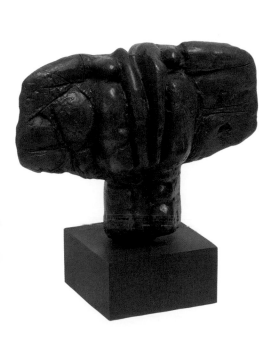

LECTURE
ROOM

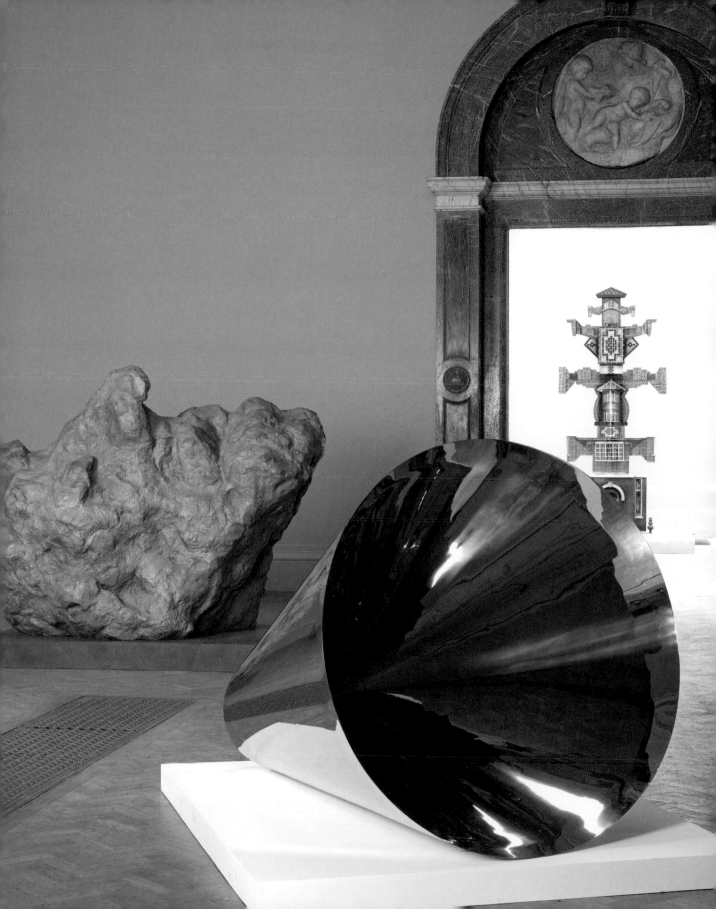

Gavin Turk
Ash
painted bronze
H 10 cm

Alison Wilding RA
Take Me to the Water
mixed media
H 122 cm

David Nash OBE RA
Red Well
madrone wood
H 116 cm

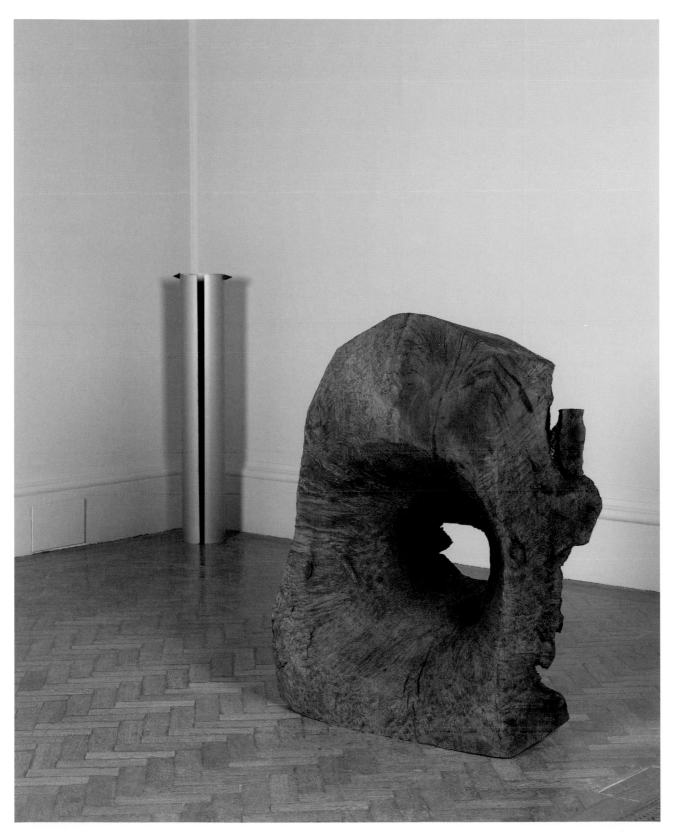

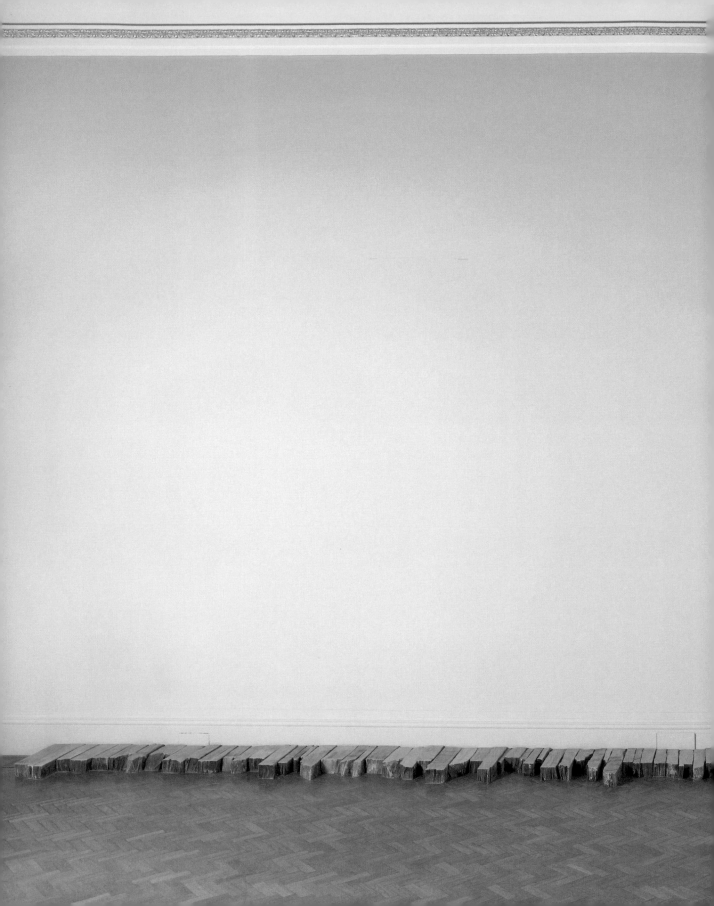

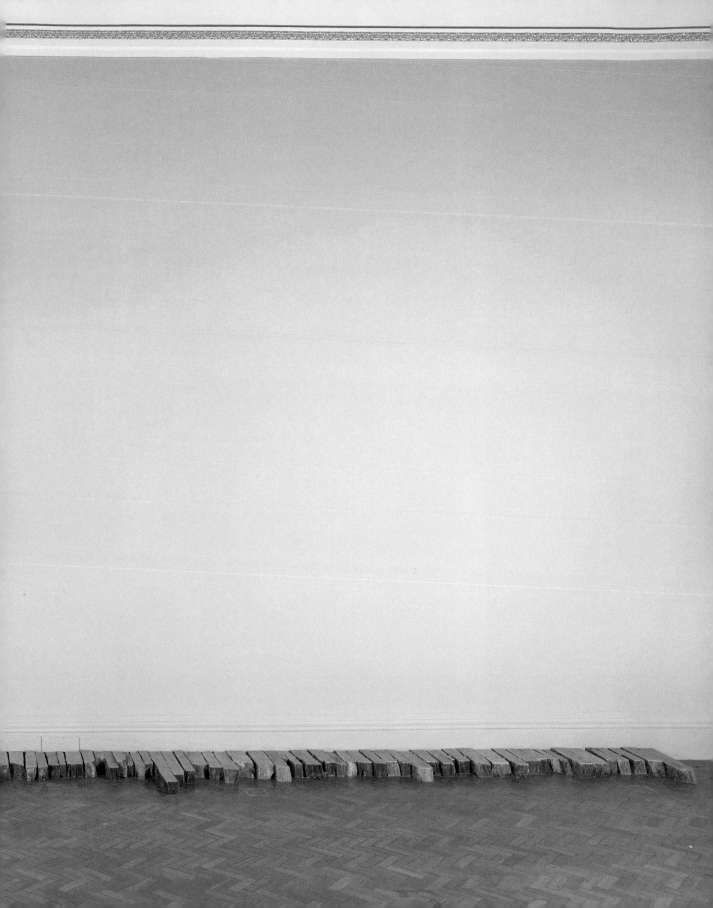

Camilla Løw
Diva
mixed media
H 220 cm

Barry Flanagan OBE RA
Empire State with Bowler
bronze
H 230 cm

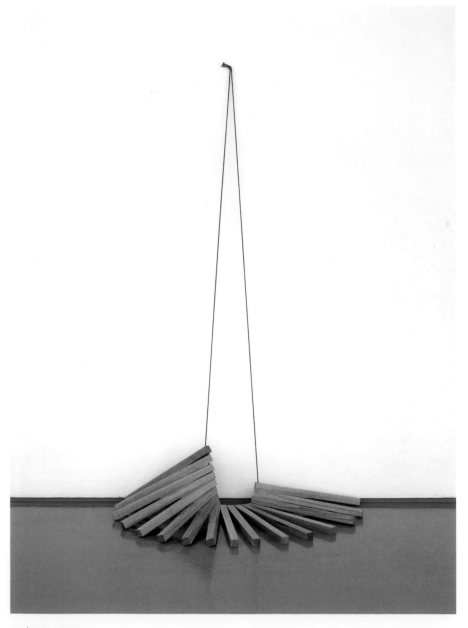

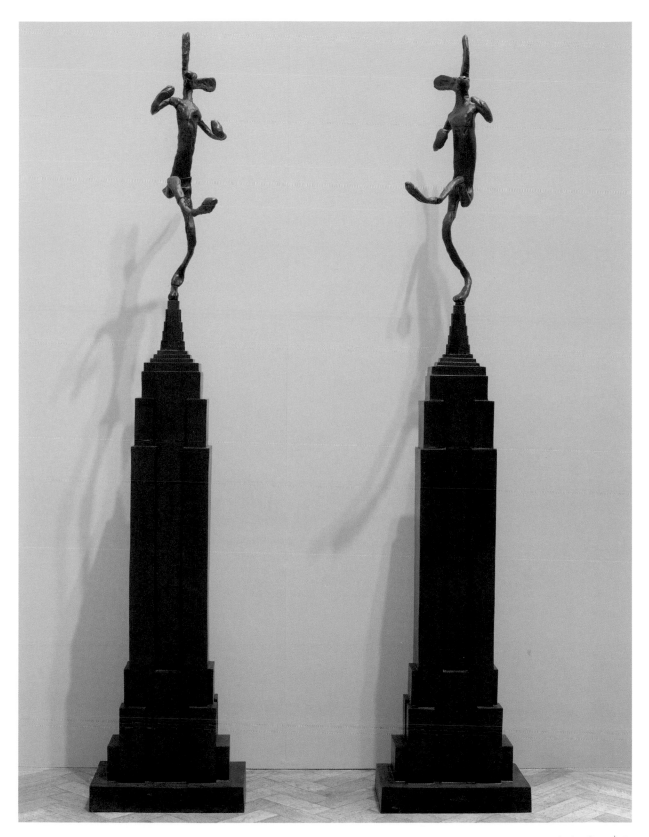

Prof Phillip King CBE PPRA
Tunis Rak
mixed media
H 125 cm

Prof Tony Cragg CBE RA
Slanted Faces
bronze
H 220 cm

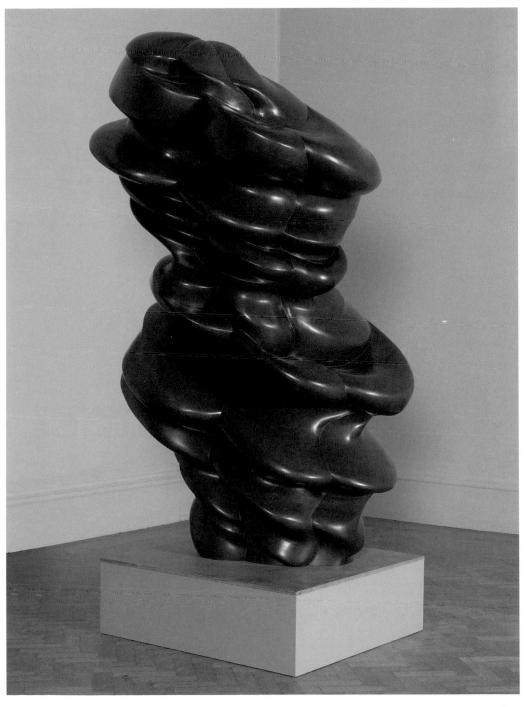

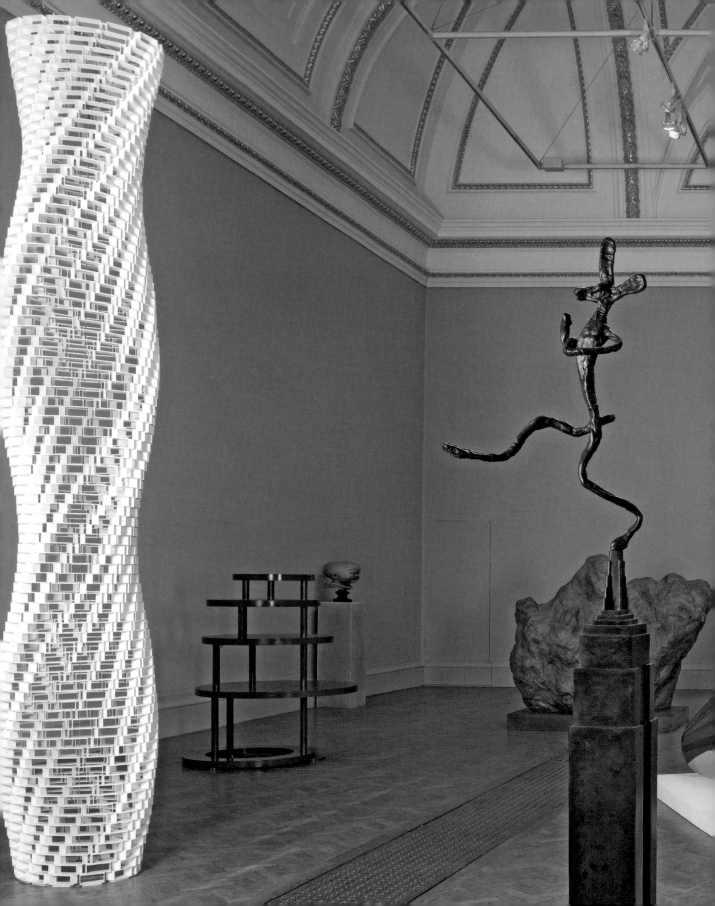

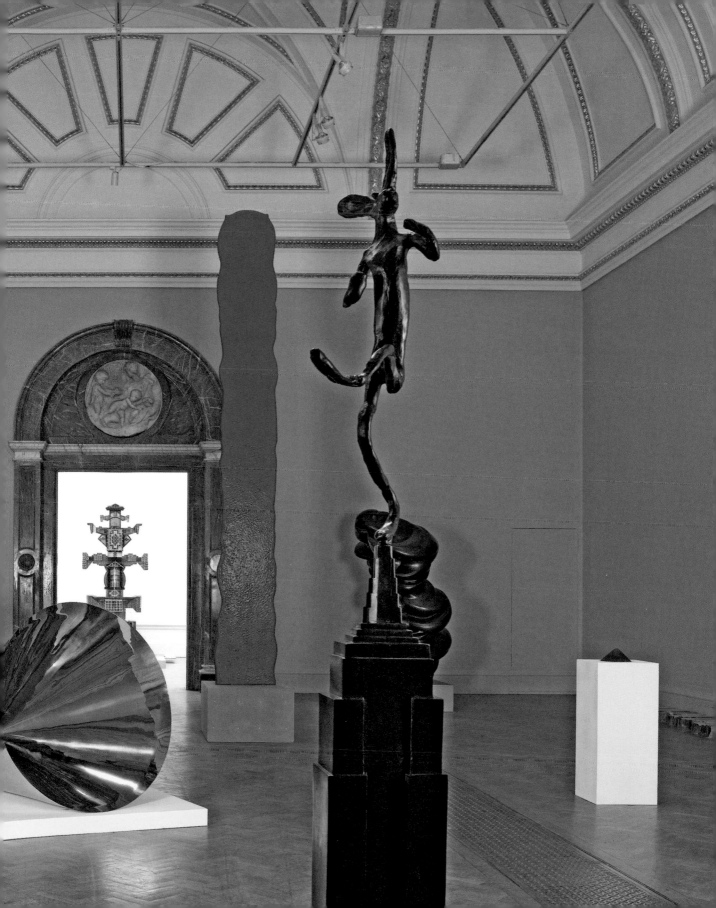

WOHL
CENTRAL
HALL

Malcolm Morley
Monster Energy
oil on linen
163 × 183 cm

Kenneth Draper RA
Spring Celebration
mixed media
58 × 64 cm

Jeff Koons
Cracked Egg
stainless steel
left: H 166 cm
right: H 89 cm

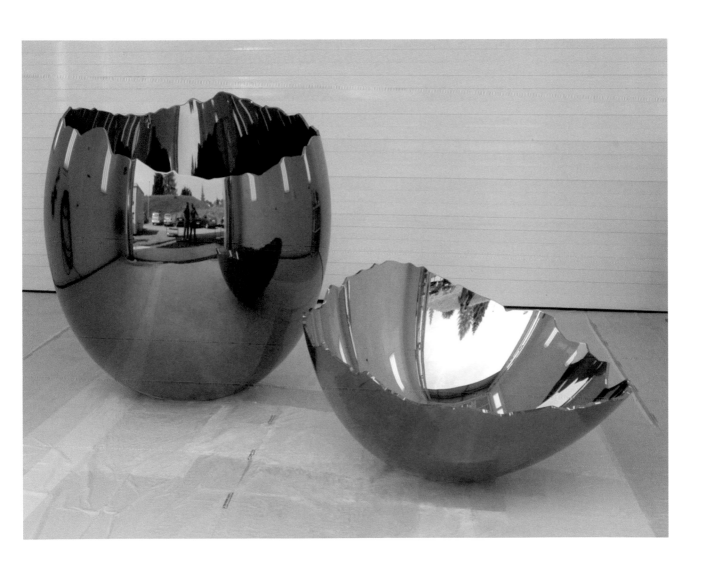

Ann Christopher RA
In Search of Light, 2
mixed media
23 × 10 cm

Prof David Mach RA
Visitor
postcard collage
190 × 190 cm

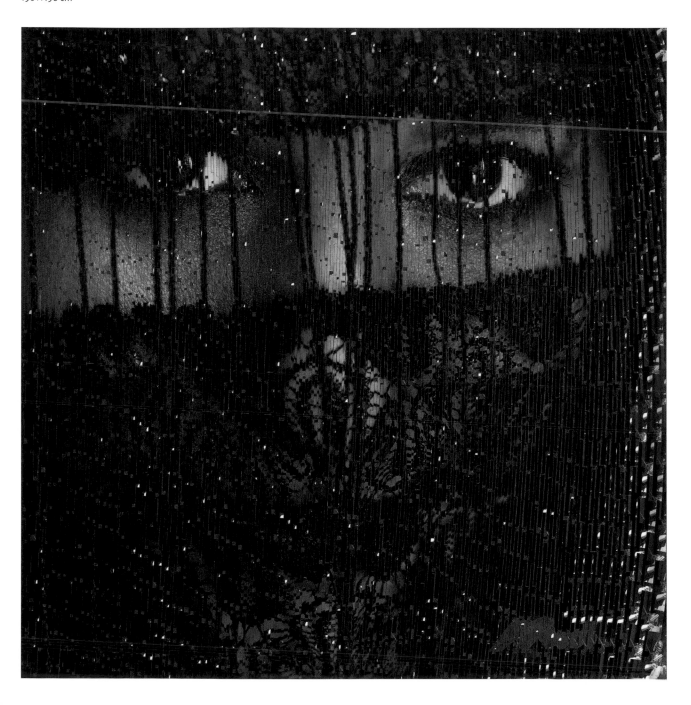

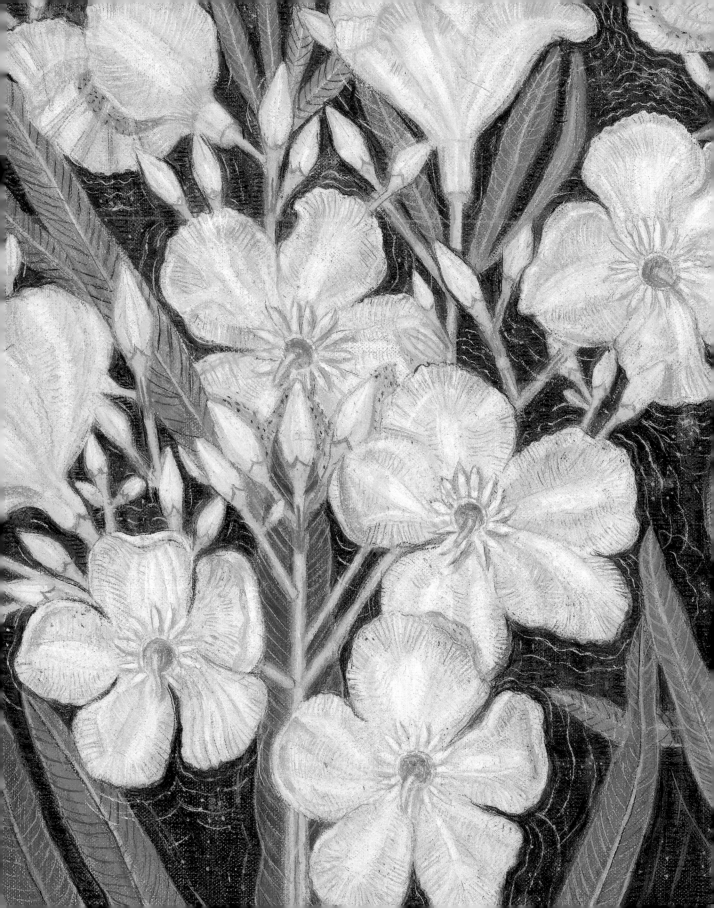

Anthony Eyton RA
Night Studio
oil
193 × 147 cm

James Butler RA
Girl Asleep
bronze
H 12 cm

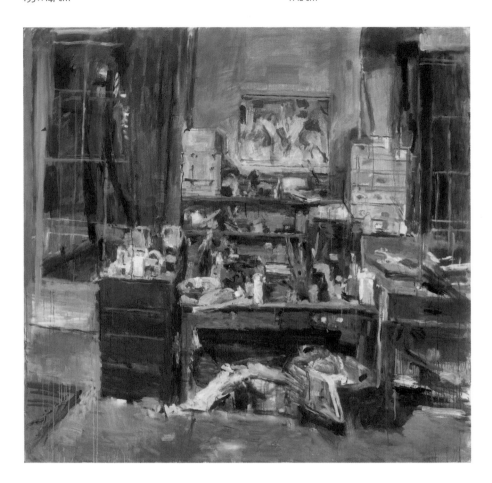

Prof Ken Howard RA
Light Effect, Campo SS. Giovanni e Paolo
oil on canvas
175 × 210 cm

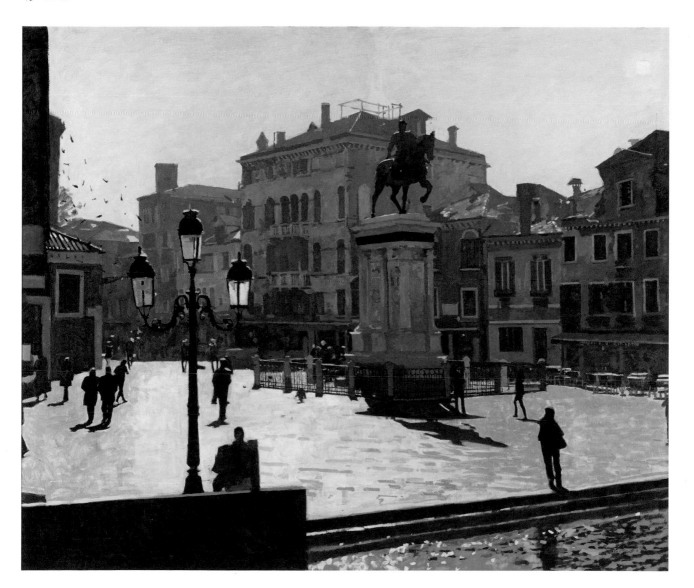

Leonard McComb RA
'Oleanders' in Homage to Vincent van Gogh
oil on canvas
59 × 48 cm

David Tindle RA
Balcony Door to Garden
egg tempera
103 × 78 cm

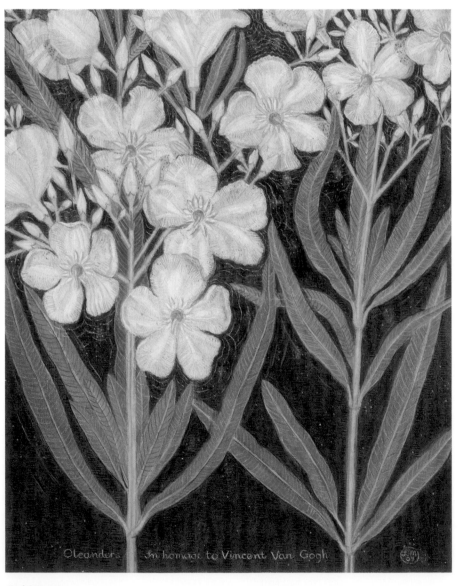

Oleanders in homage to Vincent Van Gogh

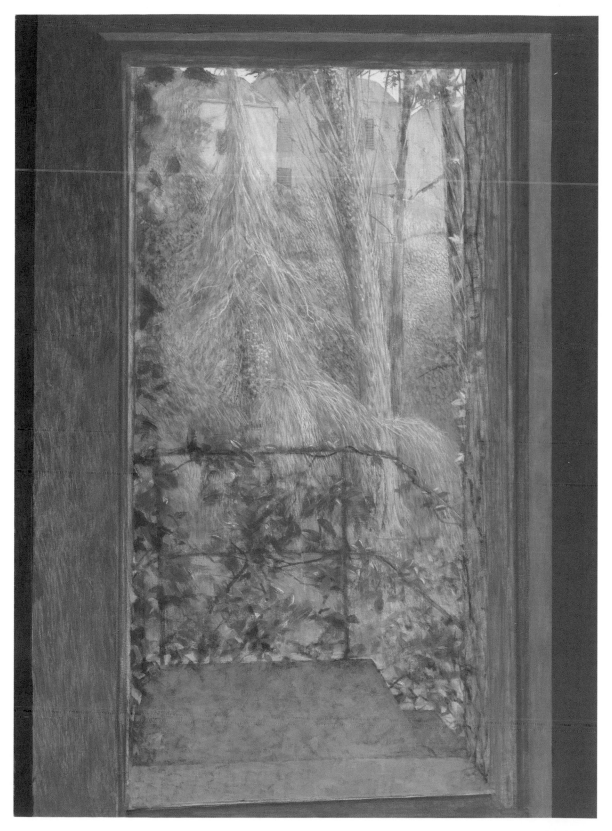

William Bowyer RA
Old Trees, Cleveland Ave, Chiswick W4
oil on canvas
108 × 120 cm

Ben Levene RA
Winter
oil on canvas
90 × 82 cm

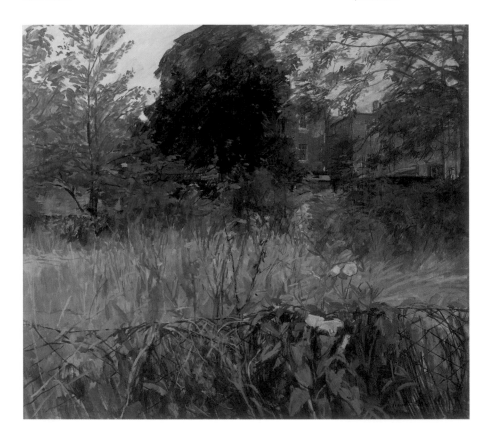

Olwyn Bowey RA
Shopping for the Garden
oil
78 × 75 cm

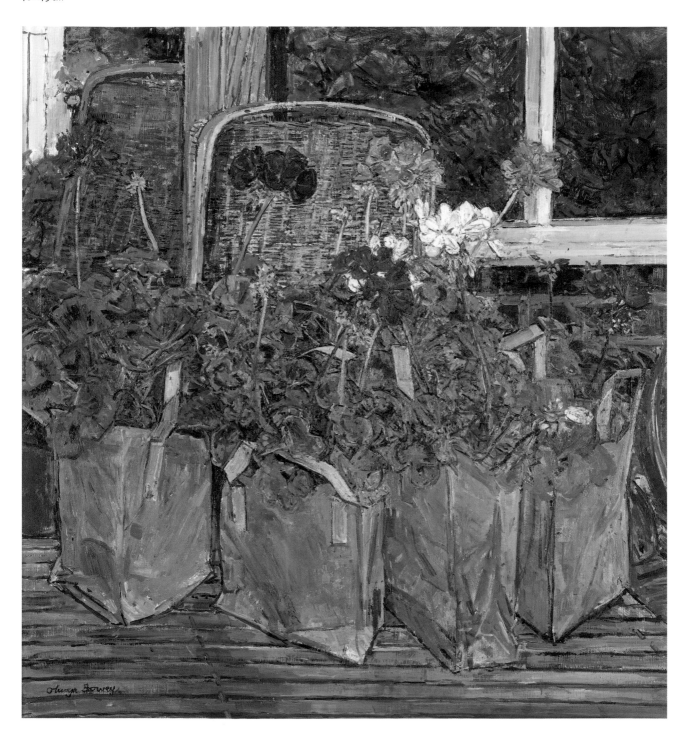

Neil Jeffries
Jolly Burrow
mixed media
H 78 cm

Jeffery Camp RA
Poppy
oil on board
63 × 60 cm

Andrew Burton
Cathedral
clay
H 28 cm

Sibylla Martin
Shela Beach Hippo
oil on canvas
124 × 95 cm

Anthony Green RA
The Old Hall, Stiffkey, Norfolk
oil on panel
214 × 346 cm

Index

Royal Academy of Arts in London, 2008

Royal Academy of Arts

The Royal Academy of Arts has a unique position as an independent institution led by eminent artists and architects whose purpose is to promote the creation, enjoyment and appreciation of the visual arts through exhibitions, education and debate. The Royal Academy receives no annual funding via the government, and is entirely reliant on self-generated income and charitable support.

You and/or your company can support the Royal Academy of Arts in a number of different ways:

- £60 million has been raised for capital projects, including the Jill and Arthur M Sackler Wing, the restoration of the Main Galleries, the restoration of the John Madejski Fine Rooms, and the provision of better facilities for the display and enjoyment of the Academy's own Collections of important works of art and documents charting the history of British art.
- Donations from individuals, trusts, companies and foundations also help support the Academy's internationally renowned exhibition programme, the conservation of the Collections and educational projects for schools, families and people with special needs; as well as providing scholarships and bursaries for postgraduate art students in the RA Schools.
- Companies invest in the Royal Academy through arts sponsorship, corporate membership and corporate entertaining, with specific opportunities that relate to your budgets and marketing/entertaining objectives.

- A legacy is perhaps the most personal way to make a lasting contribution, through the Trust endowment fund, ensuring that the enjoyment you have derived is guaranteed for future generations.

To find out ways in which individuals, trusts and foundations can support this work (or a specific aspect), please contact Darryl de Prez on 020 7300 5637 to discuss your personal interests and wishes.

To explore ways in which companies can be come involved in the work of the Academy to mutual benefit, please telephone Nathalie Glaser on 020 7300 5629.

To discuss leaving a legacy to the Royal Academy of Arts, please telephone Sally Jones 020 7300 5677.

Membership of the Friends

Registered charity number 272926

The Friends of the Royal Academy was founded in 1977 to support and promote the work of the Royal Academy. It is now one of the largest such organisations in the world, with around 90,000 members.

As a Friend you enjoy free entry to every RA exhibition and much more…

- Visit exhibitions as often as you like, bypassing ticket queues
- Bring an adult guest and four family children, all free

- See exhibitions first at previews
- Keep up to date through RA Magazines
- Have access to the Friends Rooms

Why not join today

- Onsite at the Friends desk in the Front Hall
- Online on www.royalacademy.org.uk/friends
- Ring 020 7300 5664 any day of the week

Support the foremost UK organisation for promoting the visual arts and architecture – which receives no regular government funding. *Please also ask about Gift Aid.*

Summer Exhibition Organisers
Chris Cook
Edith Devaney
James Finch
Katherine Oliver
Swapna Reddy
Paul Sirr
Jessica Smith
Matthew Turtle

Royal Academy Publications
Lucy Bennett
David Breuer
Sophie Oliver
Peter Sawbridge
Sheila Smith
Nick Tite

Book design: 01.02
Photography: John Bodkin,
 DawkinsColour
Colour reproduction: DawkinsColour
Printed in Italy by Graphicom

Copyright for the illustrations is
strictly reserved for the owners
by the *Royal Academy Illustrated*.

Copyright © 2008
Royal Academy of Arts

British Library
Cataloguing-in-publication Data
A catalogue record for this book
is available in the British Library

ISBN 978-1-905711-12-3

Illustrations
Page 2: Barbara Rae CBE RA, *Urban Decay* (detail)
Pages 4–5: Sir Anthony Caro OM CBE RA, *Promenade*. Painted steel, h 4900 cm
Page 6: Tatiana Echeverri Fernandez, *Frauleins Christina, Panthea, Zenobia, Semiramis and Guinevere* (detail). Mixed media, various heights
Pages 8–9: Anthony Eyton RA, *Night Studio* (detail)
Page 11: Prof Michael Sandle RA, *St George's Horse*. Bronze, h 180 cm
Page 12: Ron Arad, *Ping-pong Table*. Stainless steel, h 83 cm. Georg Baselitz Hon RA, *Freund 66 (Remix)*. Oil on canvas, 304 × 254 cm
Page 15: Sir Anthony Caro OM CBE RA, *Promenade* (detail)
Page 23: R B Kitaj RA, *Juan de la Cruz*, 1967. Acrylic on canvas, 183 × 152 cm
Page 29: The late Prof Sir Colin St John Wilson OM CBE RA, *The British Library, St Pancras*. Installation in Gallery IV
Page 35: Ryan McGinness, *2007* (detail)
Page 53: Jean Cooke RA, *Dream Dream* (detail)
Pages 58–59: Installation in the Small Weston Room
Page 69: Lisa Milroy RA, *Tuesday Afternoon* (detail)
Page 89: Mark Francis, *Collider* (detail)
Pages 102–103: Ron Arad, *Ping-pong Table*
Page 119: Hélène Binet, *Eglise Saint-Pierre de Firminy-Vert* (detail). Photographic print, 86 × 210 cm
Pages 131: Prof Chris Orr RA, *General Strike, or a Good Day Out* (detail)
Page 141: Rachel Kneebone, *In the Midst of Quietness Branched Thoughts Murmur* (detail)

Pages 146–147: Installation in Gallery VIII
Page 151: Installation in Gallery IX. Foreground: Paul de Monchaux, *Uxmal*. Bronze, h 37 cm
Page 159: Anish Kapoor RA, *Untitled*. Stainless steel, h 127 cm. William Tucker RA, *Emperor*. Bronze, h 174 cm
Pages 162–163: Richard Long RA, *Summertime Blues Line*. Slate, h 11 cm
Pages 168–169: Installation in the Lecture Room
Page 171: Prof Norman Ackroyd CBE RA, *Windermere in Winter*. Etching on stainless steel, 320 × 295 cm
Page 177: Leonard McComb RA, *'Oleanders' in Homage to Vincent van Gogh* (detail)

Photographic Acknowledgements
Pages 6 and 146–147: Courtesy of Tatiana Echeverri Fernandez and Carl Freedman Gallery, London
Page 12 (on the wall): Courtesy of the artist
Page 18: Private collection. © the Estate of RB Kitaj
Page 20: © the Estate of RB Kitaj
Page 21: Martin Charles
Pages 36, 42, 43 (top), 44, 48 (bottom): Published by Pace Editions, Inc.
Page 37: Courtesy of Sutton Lane, London
Page 50 (top): © Pratt Contemporary Art
Page 50 (bottom): Courtesy of the artist
Page 51: Courtesy of the artist
Page 90: Courtesy of the artist and Haunch of Venison
Page 91: Courtesy of the artist
Pages 119 and 122: © Gesch Wüfel
Page 120 (bottom): Courtesy of the architects
Page 121 (top): © Foster and Partners
Page 128 (bottom): Courtesy of the artist
Page 129 (top): Courtesy of the artist. Photography by Richard Davies
Page 142: © private collection
Page 143: © The Collection of Sir Elton John and David Furnish
Page 144: Courtesy of the artist
Page 145 (top): Courtesy of the artist and Anna Schwartz Gallery, Sydney
Page 145 (bottom): Courtesy of the artists
Page 148 (top): Courtesy Hauser & Wirth Zurich London
Page 148 (bottom): © the artist. Courtesy of the artist and Jay Jopling/White Cube, London. Photo: Stephen White
Page 149: © Julian Schnabel. Courtesy of Robilant and Voena, London and Milan
Page 160: Courtesy of Live Stock Market
Page 164: Courtesy of Waddington Galleries, London
Page 165: © Sutton Lane
Page 173: © Jeff Koons. Courtesy of a private collection